Watercolor
Made Easy

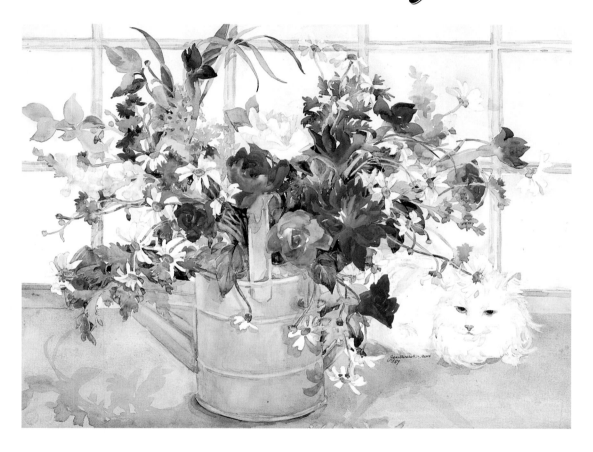

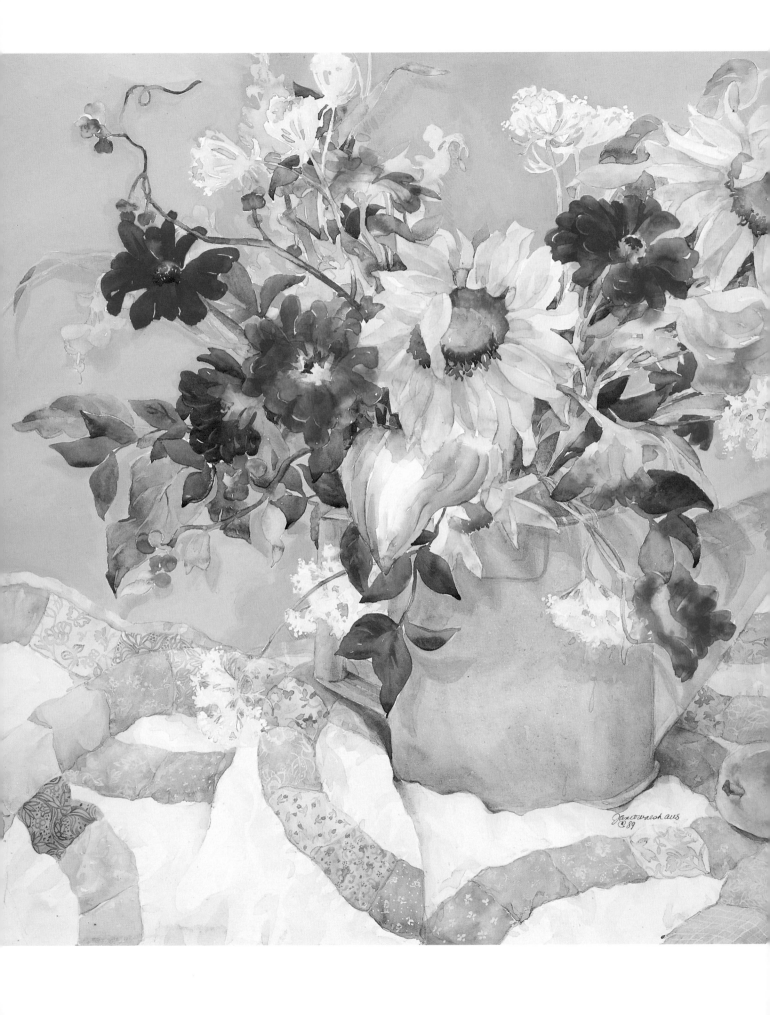

Watercolor Made Easy

TECHNIQUES FOR SIMPLIFYING THE PAINTING PROCESS

Janet Walsh

WATSON-GUPTILL PUBLICATIONS

New York

NOTES ON THE ART

On page 1:
LONNIE
Watercolor on 140-lb. Fabriano cold-pressed. 22 x 30 inches (55.9 x 76.2 cm). Private collection.

On pages 2–3:
VERMONT MORNING
Watercolor on 140-lb. Fabriano cold-pressed. 22 x 30 inches (55.9 x 76.2 cm). Private collection.

On page 5:
MOUNTAIN BOUNTY
Watercolor on 140-lb. Fabriano cold-pressed. 22 x 30 inches (55.9 x 76.2 cm). Private collection.

On pages 6–7:
FALL'S LAST FLING
Watercolor on 140-lb. Fabriano cold-pressed. 22 x 30 inches (55.9 x 76.2 cm). Private collection.

On page 8:
GIVERNY
Watercolor on 140-lb. Arches cold-pressed. 22 x 15 inches (55.9 x 38 cm). Private collection.

Copyright © 1994 by Janet Walsh

Published in 1994 in the United States
by Watson-Guptill Publications,
a division of BPI Communications, Inc.,
1515 Broadway, New York, N.Y. 10036

Library of Congress Cataloging-in-Publication Data

Walsh, Janet.
 Watercolor made easy: techniques for simplifying the painting
process/Janet Walsh.
 p. cm.
 Includes bibliographical references and index.
 ISBN 0-8230-5657-0
 1. Watercolor painting—Technique. I. Title.
ND2420.W34 1994
751.42—dc20 94-12267
 CIP

Distributed in Europe (except the United Kingdom), South and Central
America, the Caribbean, the Far East, the Southeast, and Central Asia by
Rotovision S.A., Route Suisse 9, CH-1295 Mies, Switzerland.

Distributed in the United Kingdom by Phaidon Press, Ltd., 140 Kensington
Church Street, London W8 4BN, England.

Printed in China

First printing, 1994

5 6 7 8 9 / 02 01 00 99

Senior Editor: Candace Raney
Associate Editor: Joy Aquilino
Designer: Jay Anning
Production Manager: Hector Campbell

I dedicate this book with much love and gratitude
to two of the most important men in my life:
Mario Cooper, my teacher and mentor, whose
brilliance kindled my love of watercolor;
and Bernie Gloisten, my husband, business manager,
and gardener, whose patience, humor, and affection
have been an endless source of support.

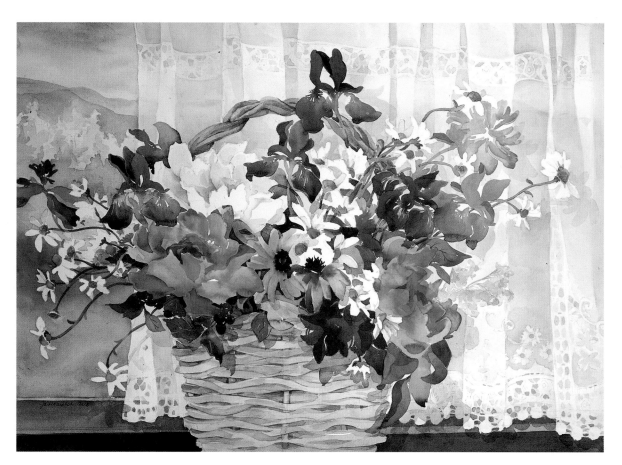

Although the cover states that I alone am the author of this book, I would have been unable to share it with you without the efforts of the Watson-Guptill staff. Candace Raney challenged me to try my hand at writing and made vital suggestions that gave me the confidence to do it. A big hurrah to Joy Aquilino, who edited my text with empathy and compassion, and who tactfully eliminated my dangling participles. My thanks also to Jay Anning, who imaginatively conceived its innovative design, and to Hector Campbell, who expertly managed its production.

Contents

Introduction

For many artists, the process of creating a painting involves the solution of a visual problem, in that all the elements of the image—the pieces of the puzzle, so to speak—must work together in order to successfully represent the subject and express the artist's feelings about it. In watercolor painting this process is frequently complicated, and sometimes even disrupted, by the very qualities that attract artists to the medium in the first place—its immediacy, spontaneity, and versatility. Beginning watercolorists routinely resist these unique characteristics, often in pursuit of a somewhat questionable ideal of visual "accuracy" whose objective is to depict every detail. By doing so, they inadvertently sacrifice the subject's spirit and the painting's focus. Fortunately, with hard work and a commitment to learning new techniques and attitudes (and, in some cases, unlearning a few old ones), this fundamental misunderstanding of the medium can be rectified.

This book shows you how to simplify your approach to watercolor painting and your observations of subject matter. It is not about carefully filling in pencil sketch lines with watercolor, but about how to use the unique qualities of the medium so that they complement and enhance the efforts of the artist and the "feeling" of both the subject and the composition. The emphasis is on the simplification of form based on relationships among individual shapes. Rather than leading to a fragmented look, my technique, which involves using two brushes—one to lay in color, the other to manipulate form—results in soft shapes and blended colors. Starting with and then building on the focal point of the composition and working toward integrating its supporting elements—such as containers for flowers, fabrics, and backgrounds—each step-by-step demonstration is accompanied by an in-depth description of the process of the painting, indicating major points of development and where and why specific adjustments were necessary. Many books and workshops on still life in watercolor overlook or gloss over these elements, whose treatment is absolutely integral to the success of any still life painting, regardless of medium. It's important to note that a composition's supporting elements can be just as stimulating and challenging to paint as those that play the leading role.

If you're serious about learning to paint, start by establishing a few routines. If you lack a spare room to set up your gear, find a little niche that you can call your own, even if only for fifteen or twenty minutes a day. Make it a habit to carry a sketchbook. Sketch whenever you can, both in pencil and in watercolor—in restaurants, gardens, playgrounds, trains, or when you're just gazing out your window—you'll be pleasantly surprised at how quickly your skills improve. You'll also learn how to express the effects of different kinds of light on each subject's color, experience that becomes critical when you're ready to try your hand at painting outdoors.

It's important to your development as an artist that you establish a strong artistic foundation by attending at least a few art classes or workshops, and studying color mixing and theory and developing basic drawing skills will provide a firm cornerstone. While working in New York City, I started by taking one class per week, and eventually attended the Art Students League and the School of Visual Arts simultaneously five evenings per week as well as all day on Saturday. My classes were my greatest source of energy and inspiration: Exhausted from the pressures of the workday, I would leave the office to attend class, which completely absorbed and exhilarated me. The comradery shared among fellow artists can also be stimulating and fulfilling. I've met and had the privilege of cultivating relationships with some very special people that I would have otherwise missed had I not pursued my interest in art.

Watercolor painting—and making art in general—offers its practitioners many rewards. I find that it's an excellent way to relax, and it gives me a great sense of satisfaction. It must be said, however, that the journey one takes in order to become an artist is never ending. As Sir Winston Churchill once said, "When I get to heaven I mean to spend a considerable portion of my first million years in painting, and so get to the bottom of the subject." I hope that *Watercolor Made Easy* marks either the start of your journey or an unexpected turn in the road on an already exciting excursion, in that it rejuvenates your perception of nature and your vision of it in your art.

CHAPTER ONE

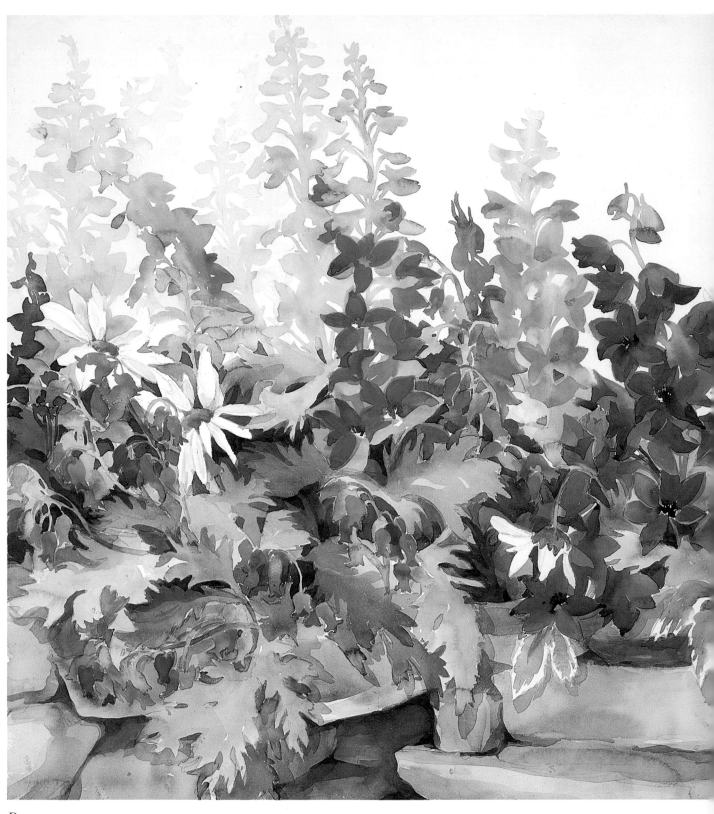

DELPHINIUMS
*Watercolor on 140-lb. Arches cold-pressed. 22 x 30
inches (55.9 x 76.2 cm). Collection of the artist*

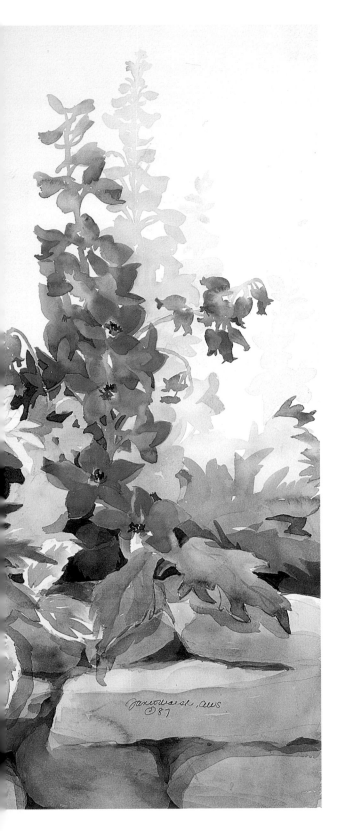

Materials and Equipment

In the process of painting a watercolor, an artist makes many creative choices, including the selection of subject matter, its treatment (realistic or abstract), and the type of watermedia used (transparent or opaque). The outcome of a painting can also be affected even before you've touched the paper with a brush, a result of your choice of materials. My selection, which has evolved over many years, reflects what I am most comfortable with and best fits my needs. I am confident in recommending all of the products discussed in this chapter, but I strongly suggest that you experiment with others as well.

If you're serious about painting, try to set up a small studio in your home. If you're new to watercolor painting and you're on a limited budget, all you need are three tubes of paint representing the primary colors—cadmium lemon (yellow), alizarin crimson (red), and phthalo blue (blue)—a round and a flat brush, a palette, and a sketchbook. Other basic supplies—pencils, tissues, and water containers—can easily be found around the house.

Although the basic elements of watercolor painting—paper, brushes, paints, palette, and water—remain the same regardless of where you choose to work, materials for studio painting are different from those for painting on location. When I'm in my studio I'm working in a controlled environment, and all my materials are readily available. On location, my primary concerns are ease of handling and portability. Embodying both these qualities, the sketchbook is the perfect on-location companion for the watercolorist, and since you can take it wherever you go it can quickly become a reflection of your personality.

FOR THE STUDIO

The studio is where most artists begin to learn to paint. You can set one up in virtually any room in your home. There are several items that you'll need to adequately stock your watercolor studio.

PAPER

Because paper is such a critical component of a watercolor painting, you should buy the best that you can afford. The quality of the paper affects the way that the paint moves on its surface, the degree to which it absorbs and retains moisture, and the brightness of the sheet. Paper is available in a range of surfaces (rough, cold-pressed, and hot-pressed), weights (from 70 to 300 pounds), and sizes (in sheets from 22 x 30 to 26 x 40 inches, and in blocks and rolls). Although blocks are more expensive than loose sheets, they eliminate the need for stretching the paper to keep it from buckling and can function as a painting board. Before you purchase a substantial supply of any brand or type of paper, I recommend that you try mixed sample packs, which may be obtained either directly from the paper manufacturer or from an art supply store. Note, however, that you will need to use one kind of paper in several paintings before becoming thoroughly acquainted with it.

My paper preferences have evolved over many years. For florals, I prefer 140-pound cold-pressed Fabriano or Lanaquarelle, both of which are bright white and have the right amount of "tooth," or texture, to respond favorably to color. Both sides of these papers are appropriate for painting—not just the side with the watermark—and because they don't contain a lot of sizing, I don't have to worry about stretching them. For plein air or outdoor painting, I sometimes stretch my paper if I know that a painting will have large areas of washes. Arches and Lanaquarelle 140-pound cold-pressed are ideal for this process because they are both sturdy enough to endure repeated washes.

BRUSHES

The three essential characteristics of a good watercolor brush are flexibility, a good point, and "spring," which means that it resumes its original shape after being pressed onto the paper. The kind and size of brush I use depends on what I'm painting, either still lifes or plein air subjects, as well as on the surface of the paper.

Good brushes are indispensable in watercolor painting. I often see students in my classes struggle with brushes that look like they've been used to scrub floors, a fact that is inevitably reflected in their work. This problem is both unnecessary and avoidable, as there are many inexpensive good-quality watercolor brushes on the market. I typically use the following brushes:

Winsor & Newton Series 995 3/4-inch flat nylon, Cheap Joe Art Supply Waterhawk and *Jack Richeson Series 9000 Nos. 10 and 12 Round.* I use a round brush and a flat brush simultaneously: I generally apply color with the round, then immediately use the flat to soften edges. The Cheap Joe brush is a mix of natural and synthetic hairs, while the Jack Richeson is synthetic only.

Cheap Joe Sky Hawk 2-inch Flat. I use this brush, which is a mix of natural and synthetic hairs, to wet the paper when I work wet-in-wet or to lay down large washes.

Despite their exorbitant cost, which could be as high as a few hundred dollars, you might consider buying one or two sable brushes. These are the best watercolor brushes on the market and can last many years. I recommend Isabey 6228 No. 8 Round, Isabey 6227Z Nos. 6 and 12 Round, and Isabey 6238 No. 8 Flat.

PAINTS

The following is my current selection of watercolors, which I find works very well with a range of subjects.

Cadmium Lemon	Jaune Brillant #2
Indian Yellow	Cadmium Orange
Cadmium Scarlet	Cadmium Red
Winsor Red	Alizarin Crimson
Permanent Rose	Raw Umber
Raw Sienna	Burnt Umber
Burnt Sienna	Permanent Magenta
Helios Purple	Cobalt Violet
Winsor Violet	French Ultramarine
Cobalt Blue	Phthalo Blue
Cerulean Blue	Cobalt Turquoise
Phthalo Green	Permanent Green Light #1
Payne's Gray	

As good-quality watercolors can be costly, I recommend that you purchase one of each color family to start, then expand your selection as needed. Whatever colors you choose, experiment with various mixtures and keep records. For instance, you might note a color's number of possible values, its degree of opacity or translucency, and whether its texture is grainy or smooth.

PALETTE

For many years I've used a John Pike Palette, which is made of heavy-duty plastic, has ample mixing space, and is fitted with a cover that keeps paints from drying out. I also use a Cheap Joe X-tra Color Palette, which is an extra-small, sixteen-section palette for colors that I'm currently testing or that I use only occasionally.

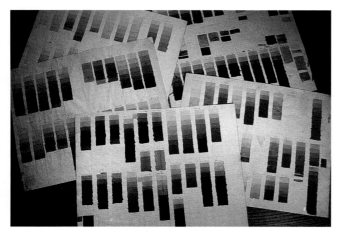

By making your own color charts you will be able to clearly understand and anticipate dozens of color mixtures.

I use Cheap Joe Art Supply Fritch Scrubbers to lift both small and large areas, or a No. 4 oil brush with the edges trimmed down at an angle on difficult stained areas.

Regardless of which palette you choose, ample mixing space is essential. Equally important is layout, which will affect how you set up your paints. Set up your colors in the same configuration as a color wheel. In this arrangement, the primaries (red, blue, and yellow) are equidistant points on a circle, and between them lie their various mixtures: the secondaries, which are mixtures of two primaries (green, violet, and orange); and the tertiaries, which are mixtures of a primary and a secondary (such as yellow-green). After you've used a palette for a few weeks you will become accustomed to its layout, so you won't have to waste any time searching for a color. The position of the palette should coincide with the hand in which you hold the brush: If you're right-handed it should be on your right, and if you're left-handed it should be on your left. Then you won't have to risk dripping paint on your work whenever you reload your brush.

MAKING CORRECTIONS

Various papers and paper weights react differently to lifting or making corrections. Some papers respond generally well, and others can take quite a bit of abuse. The sample shown above right was made with staining pigment on Arches 140-pound cold-pressed. While many watercolorists use a natural or cosmetic sponge for adding texture or for wetting the paper, I also use it for lifting large areas.

As you gain confidence in making corrections, your confidence in your painting skills will also increase. Experiment on some of your discarded paintings. I've seen areas within paintings on which the artist used sandpaper to such an extent that the paper looked almost like tissue paper when held up to the light.

OTHER EQUIPMENT

In addition to the staples of paper, brushes, paints, and a well-designed palette, there are a few other items you'll need.

Pencils. I use No. 2 pencils to sketch in the basic forms of my paintings. When I need a pencil with a really fine point, I use a Staedler Mars refillable 780 mechanical pencil, which requires a special sharpener.

Erasers. Eberhard Faber kneaded erasers, which are very gentle on paper, can be cleaned by pulling them apart like taffy. Factis erasers are also very gentle on the paper surface.

Easel. Because I work on more than one painting at a time, I use many easels: several French easels, a Logan easel, and a large handcrafted one made by Liberty Manufacturing Company, Kingston, Tennessee.

Painting board. A painting or drawing board is the surface on which the paper is mounted. It should be light and stiff, and about 1 inch wider and longer than the size of paper you use most often. Gatorboard is extremely lightweight, and Marklite, which looks like Formica, is also excellent.

Fasteners. These large metal or plastic clips are used to affix paper to a painting board.

Tracing paper. Tracing paper can be an important aid in developing a painting. I use it to sketch in contours and negative shapes, as well as to experiment with various supporting elements within a piece before painting them in.

Artist Tape. I use this brand of tape to tack tracing paper over a painting, or to attach paper to a painting board.

White Mask. This brand of liquid frisket is used to mask off areas of a painting—either painted or unpainted—so that they can be painted over and remain unaffected. (Refer to Chapter 6, "Saving and Painting Whites.")

Plastic water containers. I use two waters containers when I paint: one to rinse dirty brushes, and the other to hold clean water to mix with paint, to wet paper, and to dampen brushes.

Painting on Location

The choices I've made about which equipment to take on location are the result of many overseas trips. I finally realized that if I continued to carry around all my bulky equipment that I probably wouldn't survive to retirement age. Almost everything I travel with is lightweight and fits comfortably into a suitcase, and the items that don't are equipped with shoulder straps, making them relatively easy to transport.

Cookie Box Traveler®. I've adapted a Cookie Box Traveler to suit my personal painting needs. It's like a miniature traveling studio, specially designed to hold painting supplies. The six compartments can accommodate tubes of paint, brushes, pencils, water containers, fasteners, and a few other items. After I've packed all the smaller things I lay my palette on top. The Cookie Box Traveler can be opened to stand on its base or to lie on its side like a briefcase, so that it can be used as an easel. If you don't have studio space or a designated painting area in your home, the Cookie Box Traveler can keep your supplies handy and well organized.

Laptop computer tote bag. A laptop computer bag is also an excellent (and reasonably priced) way to transport painting supplies. Mine has two outer sleeves: My sketchpad is in the open one, always within reach, and I keep my personal effects in the one with the Velcro closure. The bag stands upright when opened and has two easy-access inner compartments: I use one to hold two water containers, brushes, and any important documents or papers, and the other to hold erasers, fasteners, facial tissues, a washcloth, paints, and other small items, then pack my palette in the divider between them. I generally store my paint tubes in a plastic bag and leave them at home or in my hotel room and take only a few on location, just in case. All the little interior pockets are also fitted with Velcro closures.

Logan Upright Easel Model 2000. This lightweight easel, which weighs just 1½ pounds and folds to a compact 22 inches, can be opened to a maximum height of 58 inches and can easily hold a 30-inch board. It comes with its own carrying case.

Viewfinder. A viewfinder is an invaluable tool for framing compositions that's as easy to make as it is to use. Measure the size of the paper you'll be working on, then divide its length and width by 4 or 5. Draw a rectangle in the reduced dimensions on a piece of cardboard, then cut it out using an X-Acto knife or razor blade. By looking through the opening you can survey your subject both horizontally and vertically, and from any angle. Adjustable viewfinders, which can also be used to size and crop photographs, are available in art supply stores.

Paper holder. To make a paper holder, cut two pieces of cardboard about 2 inches larger than the paper you'll be using, then tape them together to make a sort of folder, leaving one long side and one short side open. Cover the outside with contact paper so you can also use your paper holder as a painting board.

Denim portfolio. I use this oversized bag to carry my paper holder and paintings—both finished and still in progress—and protect them from the elements.

Folding stool. I only need to carry this with me in the United States. It seems that in other countries there are benches, or at least comfortable rocks to sit on, virtually everywhere.

Camera. Several years ago I traded my old 35mm single lens reflex for a Pentax SF10, which can be operated either manually or automatically. The automatic focus comes in handy when shooting on location, especially when taking candid shots of people. I use two lenses, both manufactured by Sigma: One has a focal length of 28–70mm; the other ranges from 75–300mm. These two lenses are appropriate for photographing subjects from many perspectives, from close-ups to wide-angle and telephoto views. In addition to the Pentax, I always take along a Polaroid camera, which enables me to assess a composition instantly. Instant-print photos are also great for capturing light effects and for simplifying values and patterns.

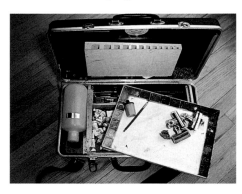

My Cookie Box Traveler is like a studio on the road. It's also a great way to keep your materials organized if your studio space is limited or temporary.

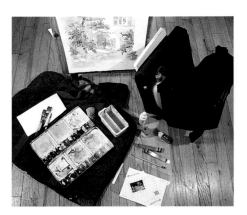

Two other ways to carry painting equipment—a denim portfolio and a laptop computer tote bag—along with a portable easel, a viewfinder, a palette, brushes, fasteners, water container, pencil, and sharpener.

My Studio and Garden

After my husband and I were married, he built a studio for me in his home in Lloyd Harbor, New York. My studio is an expansive, bright room, about 32 x 20 feet, with picture windows that overlook the surrounding garden. The vaulted ceiling and its skylights enhance the room's spaciousness. One wall is carpeted so that I can hang and rehang my work without ruining the plaster or drywall underneath. Track lighting allows me to reconfigure the artificial light as projects and seasons change. The rear entrance opens onto a deck that leads to the garden. Except for my art reference books, some of which I keep in my apartment in Manhattan, my studio accommodates all my painting equipment and gear:

Flat storage files

A sink with running water

Cabinets for storing paint supplies and fabrics

Shelves for reference material

Racks for containers

A light box

A slide projector

Stands for works in progress

Easels and tables to paint on

Since setting up shop in my studio and becoming a hands-on participant in the life of the garden, I've learned that gardening is much like painting: Nurturing a plant and painting its bloom both take time and patience, and both the gardener and the painter work with textures, groupings, colors, and rest areas to create a beautiful image or setting. My work in the garden—digging, planting, weeding, arranging, and pruning—has given me great insight into my painting, and I believe that my art is more expressive and intuitive as a result. The garden has become a very important part of my life.

While traveling in France a few years ago, my husband and I paid our first visit to Monet's garden in Giverny, which has a beautiful lily pond. I painted in the garden for three months and have many fond recollections of that time. When we returned home my husband decided to have the little pond on his property expanded. The new pond is glorious: It has a waterfall and a rustic bench where I sit watching the fish and gazing at the garden. This quiet time gives me repose to contemplate my art and plan my days.

Although several years have passed since it was first planted, the garden outside my studio is young by horticultural standards.

USING A SKETCHBOOK

As you can see by flipping through this book, a sketchbook can have many applications. I wouldn't think of going out on location without one. When I go on a trip, one of my goals is to try to fill an entire sketchbook. Sometimes I make quick sketches, take notes, or make small paintings. Back at my studio I then add the information I've gathered to my inventory of forms. Following a three-month stay in the French countryside, I returned with a stack of completed sketchbooks. Whenever I went out, rain or shine, I always took my sketchbook along, though not always to paint. During that time my drawing ability improved and my observations of nature became more effective and more finely honed.

Sketchbooks are available in a wide range of sizes, so you're sure to find one that meets your needs and fits your price range. I've always used an Aquabee Super DeLuxe 9 x 12 inch spiral-bound sketchbook, which is suitable for pen and ink, pencil, and watercolor sketching. The following pages illustrate my primary motives and goals in consistently employing the sketchbook in the development of my work.

GATHERING INFORMATION

While I do gather some visual information with my camera, using it to record details that would be too time-consuming to sketch thoroughly and to examine the designs that occur in nature, it can never become a substitute for my sketchbook. Sketching not only acquaints you with the physical appearance of your subject, but increases your sensitivity to the nuances of its context, including light, mood, and atmosphere. This heightened awareness, and your expression of it, distinguishes your work from that of all other artists.

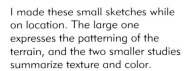

I made these small sketches while on location. The large one expresses the patterning of the terrain, and the two smaller studies summarize texture and color.

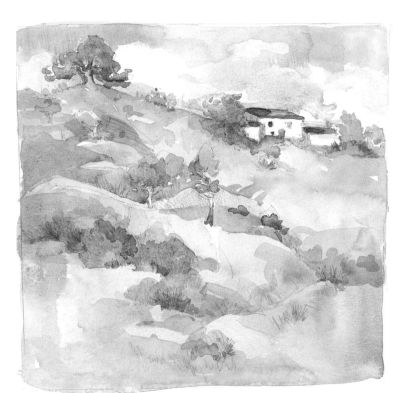

Murin-an Garden in Kyoto, Japan. Drawn by its contemplative atmosphere, I visited this restful and soothing place again and again. Sometimes I would go there just to sit and think. My quiet times energize me.

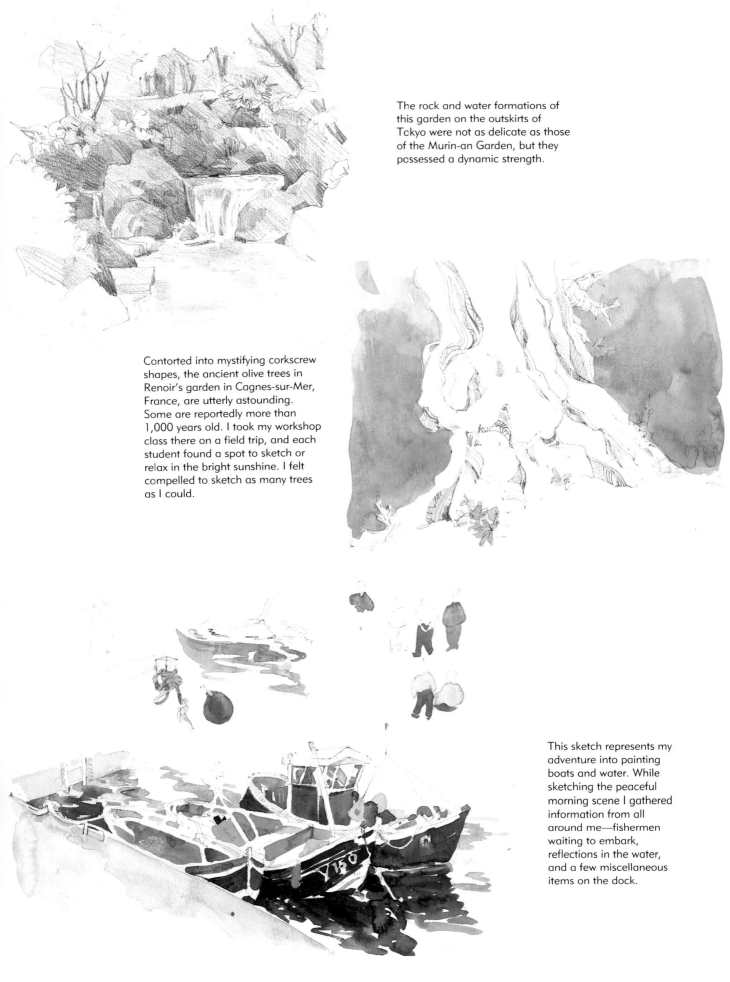

The rock and water formations of this garden on the outskirts of Tokyo were not as delicate as those of the Murin-an Garden, but they possessed a dynamic strength.

Contorted into mystifying corkscrew shapes, the ancient olive trees in Renoir's garden in Cagnes-sur-Mer, France, are utterly astounding. Some are reportedly more than 1,000 years old. I took my workshop class there on a field trip, and each student found a spot to sketch or relax in the bright sunshine. I felt compelled to sketch as many trees as I could.

This sketch represents my adventure into painting boats and water. While sketching the peaceful morning scene I gathered information from all around me—fishermen waiting to embark, reflections in the water, and a few miscellaneous items on the dock.

EXPLORING PATTERNS IN NATURE

Nature exhibits consistent relationships of line, shape, color, value, form, texture, and space that you'll encounter repeatedly in still life and plein air subjects. Learning to recognize these patterns through sketching will improve your powers of observation and strengthen your rendering skills. For example, if you look carefully you can discern many subtle relationships among the trees in a landscape: those between the branches and the trees, between the leaves and the branches, and between the background (negative) space and all the elements.

EXPLORING COMPOSITION

Before tackling your first painting, you must learn how to develop and establish an overall composition. There are two basic ways of approaching this. You might begin by composing an image in units or sections based on an intricate drawing, or by sketching it loosely as a whole. I sketched the studies shown below while on location in Kyoto, Japan, and the Hawaiian islands of Maui and Kauai. Although I drew them quickly and intuitively, I considered the composition of each study with the idea that I might expand it into a painting someday. In the examples shown directly below, I established linkage between carefully placed shapes of similar value to create three different compositions. Note also the variations in the use of negative space.

I use simple pencil studies such as these not only to gather information to draw on for future reference, but to examine various design and compositional possibilities.

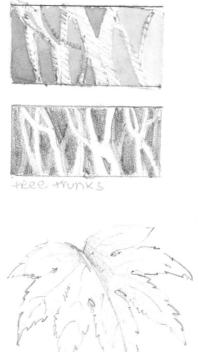

tree trunks

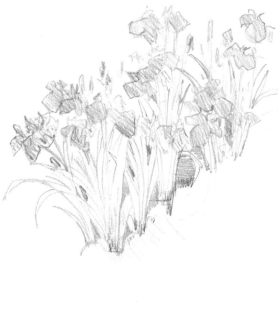

I was generally pleased with the outcome of this diagonal arrangement, but after finishing the sketch I could see that its rigid X-shaped pattern, which repeated the shape of the paper exactly, needed some adjusting.

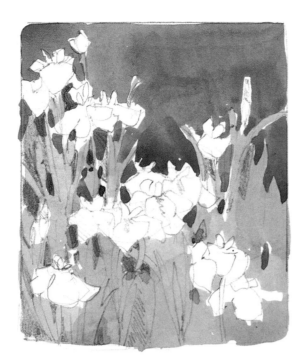

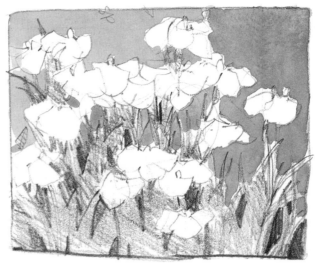

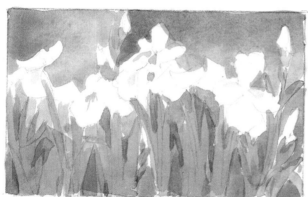

This elongated horizontal arrangement, which is somewhat static, is the least successful of the three.

The composition in this sketch was better than the first, mainly as a result of the pattern created by the white flowers that softly weaves its way through the image.

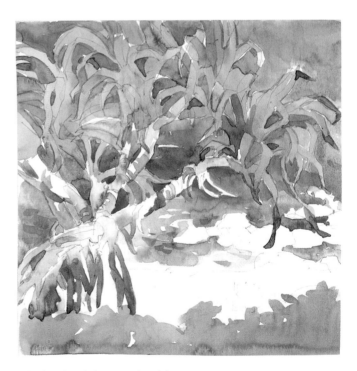

This sketch, a more complex variation on the arrangements shown above, uses an appealing range of values and shapes within a horizontal format.

In this sketch I manipulated forms to create interaction and rhythm among shapes, as well as horizontal and vertical movement within the composition.

Observing Sky Patterns

As the primary source of light, the skies of plein air and landscape paintings are critical to their composition, affecting value, mood, and pattern. Regardless of the time of day, a beautiful sky with magnificent clouds can be one of the most inspiring subjects for a watercolor painter. When my husband and I visited southern Spain during a prolonged drought (which at this writing has persisted for thirty years), we arrived by chance immediately after a downpour. As a result, I was able to observe some amazing cloud formations over the next few days. Being a native New Yorker, I especially appreciated the radiance and ethereal quality of a vast, open sky, which I usually don't have an opportunity to see.

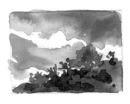
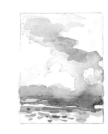

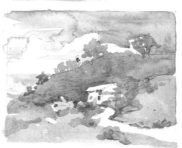

I began these six quick studies of cloud formations and color combinations at about 7:30 A.M., just as the sun began to rise.

This small painting is based on an earlier sketch as well as my memories of the approaching storm. The abandoned white farmhouses in the mountains seemed to glow against the darkening sky.

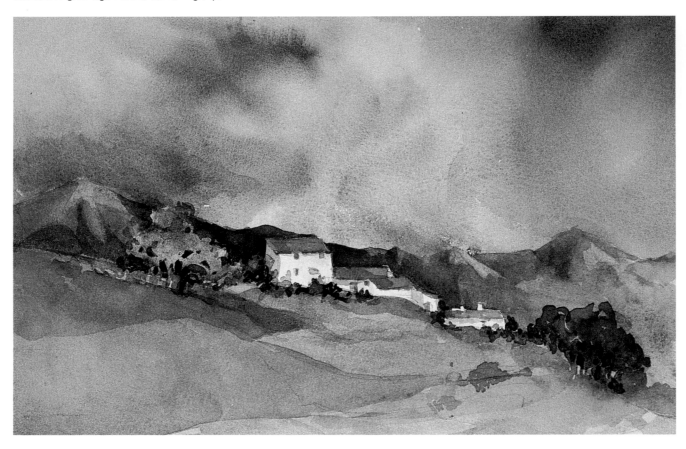

LOOKING AT STRUCTURES

Sketching and painting structures such as walls, windows, fences, cottages, or cathedrals can provide a refreshing respite from natural forms, and can be easily integrated into your floral compositions. In the same way that representing botanical accuracy isn't a primary goal of my floral paintings, I'm not particularly interested in creating exacting architectural renditions when I sketch or paint buildings. Actually, I find that buildings and various architectural elements have more character if there is a nonchalance about them—the same feeling I aspire to in my florals.

When sketching buildings, think of them as a series of interconnected shapes, usually squares and rectangles, perhaps with triangular roofs. Regardless of style or treatment, perspective—the technique of representing spatial relationships on a flat surface to create an effect similar to that perceived by the eye—is an important element in drawing buildings and landscapes. Starting at eye level, squint and hold your brush even with your line of vision, then fix an imaginary horizon line on the surface of the paper. Horizontal parallel lines that fall above it, and those that recede, are drawn in a downward direction, and those that fall below it are drawn up. To further enhance depth in an image, consistently reduce the sizes of objects such as buildings, trees, or the width of a road as they recede in the picture plane.

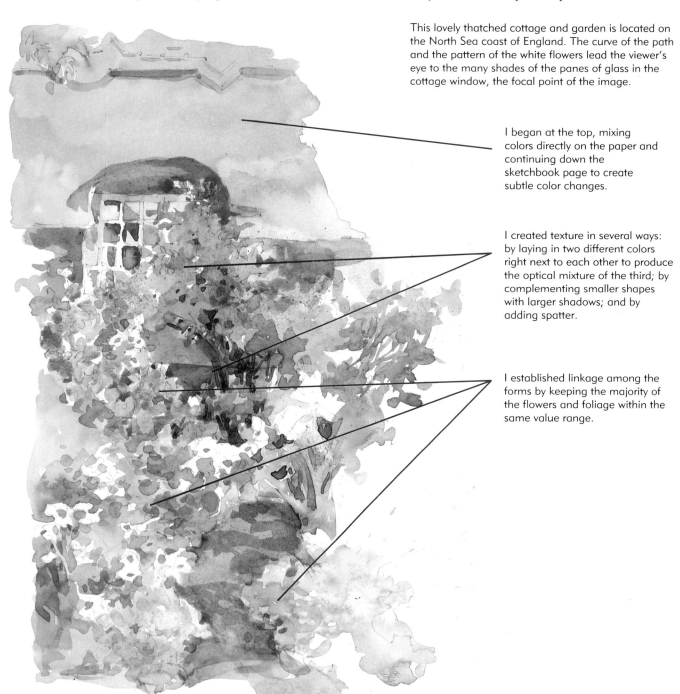

This lovely thatched cottage and garden is located on the North Sea coast of England. The curve of the path and the pattern of the white flowers lead the viewer's eye to the many shades of the panes of glass in the cottage window, the focal point of the image.

I began at the top, mixing colors directly on the paper and continuing down the sketchbook page to create subtle color changes.

I created texture in several ways: by laying in two different colors right next to each other to produce the optical mixture of the third; by complementing smaller shapes with larger shadows; and by adding spatter.

I established linkage among the forms by keeping the majority of the flowers and foliage within the same value range.

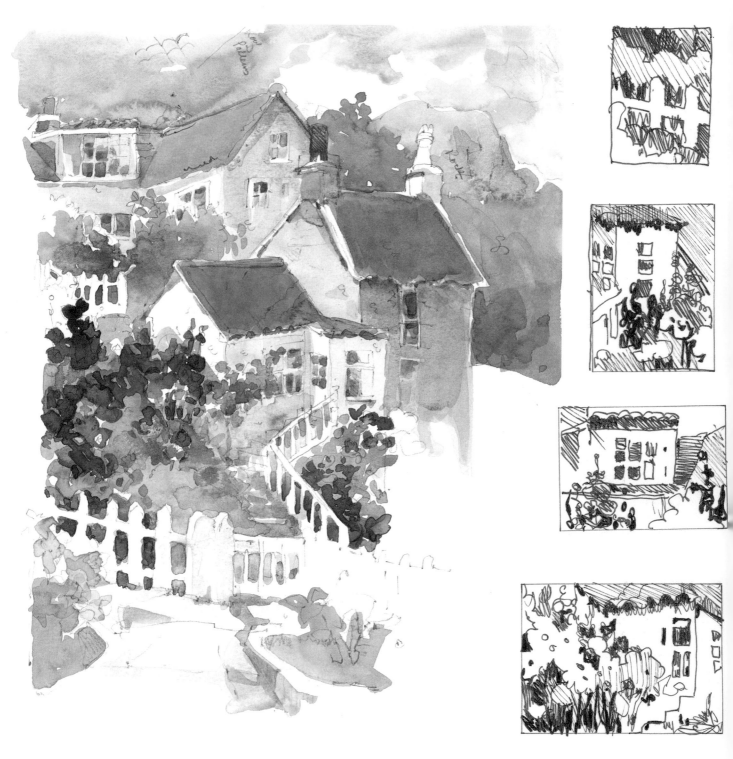

This part of the village was perched on a hillside that zigzagged down to the sea. From the top of the hill to the seawall below were cottages and cascading gardens, interspersed with gigantic red hollyhocks and a meandering white picket fence. My task here was to determine which elements to eliminate while preserving the mood of the scene. The composition and colors shown here will serve as reminders for the large painting I'm planning to do—and I always have the option of changing them as I work. I will continue to edit the image; I would like to leave out the rock in the upper right-hand corner and the portion of picket fence on the lower far left above the flowers. I can even use this one sketch, which took me a little more than an hour to complete, as a source for an entire series of paintings, whose possible compositions I can evaluate by making some simple pen-and-ink drawings.

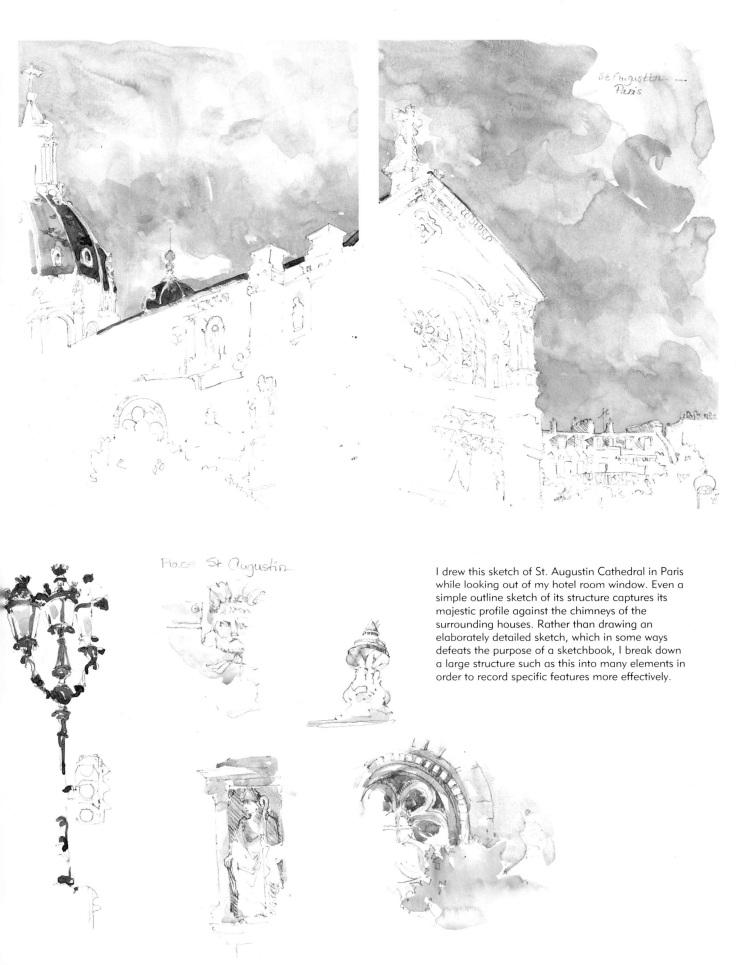

I drew this sketch of St. Augustin Cathedral in Paris while looking out of my hotel room window. Even a simple outline sketch of its structure captures its majestic profile against the chimneys of the surrounding houses. Rather than drawing an elaborately detailed sketch, which in some ways defeats the purpose of a sketchbook, I break down a large structure such as this into many elements in order to record specific features more effectively.

SKETCHING PEOPLE

Although the majority of my work doesn't feature people, I enjoy drawing and photographing them when I travel. Looking through your sketchbooks at people you've drawn can bring back wonderful memories, from which you can also draw impressions and images. The addition of people, animals, or even boats to a landscape can create interest and depth in a painting. The sketches below and on the opposite page depict people in a series of simple shapes, but they serve more than adequately as reference material.

If you would like to paint figures but you're feeling a little intimidated, start with a few individual figures reduced to basic shapes, then try small groupings of figures, and then gradually work your way up to small compositions.

In addition to drawing and painting simple figure studies such as these, I sketch more complete drawings of people every chance I get—on the train or bus, at the seashore or a concert, or in restaurants. In Paris my favorite sketching spots were sidewalk cafés. I carry my sketchbook in an open portfolio so that I can reach for it without attracting too much attention. If I photograph someone I try to do it from a distance using a telephoto lens so as not to disturb my subjects. I generally do these kinds of sketches quickly and loosely, basically as contour drawings. Some are composition studies and others serve as "warm-ups" for other work. The most important requirement for sketching is simply to do it, and to do it often.

Hanging around in an airport while you're waiting to board your plane can be a great opportunity to take advantage of an overabundance of free models. In this sketch, I was able to capture the animated gestures and conversation of my two subjects. The simple band of foliage serves to advance the figures within the composition and to generally unify it.

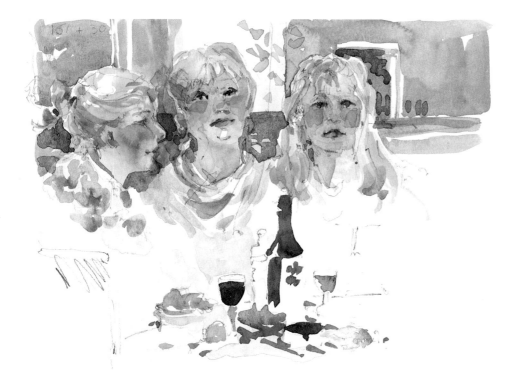

These three young American women were all smitten with their handsome French male companion. Although this sketch was intuitively drawn, it reveals the look of ardor in their faces.

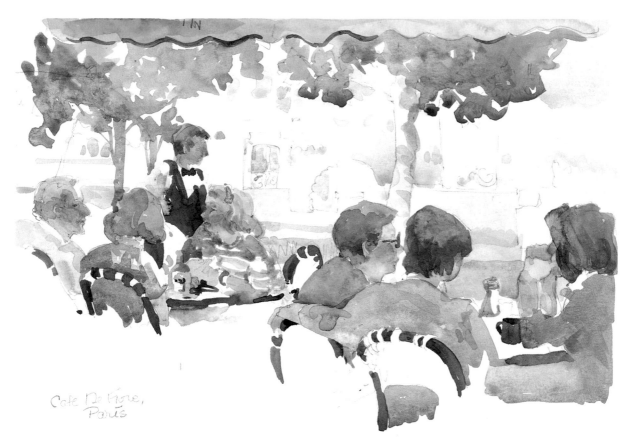

Café De Flore, Paris

This sketch of the Café de Flore in Paris is a study for a future painting. I will also use the many photographs that I took of the site to help me recall details and provide basic guidelines for color and value relationships. The dark patterns of the chairs lead the eye through the image, connecting the two groups of figures. Rather than paint them in their actual local colors (red and black), which would have diverted attention from the figures, I opted for a single, more neutral color. With this in mind I also treated the background simply, using only suggestions of shapes for the buildings and street.

CHAPTER TWO

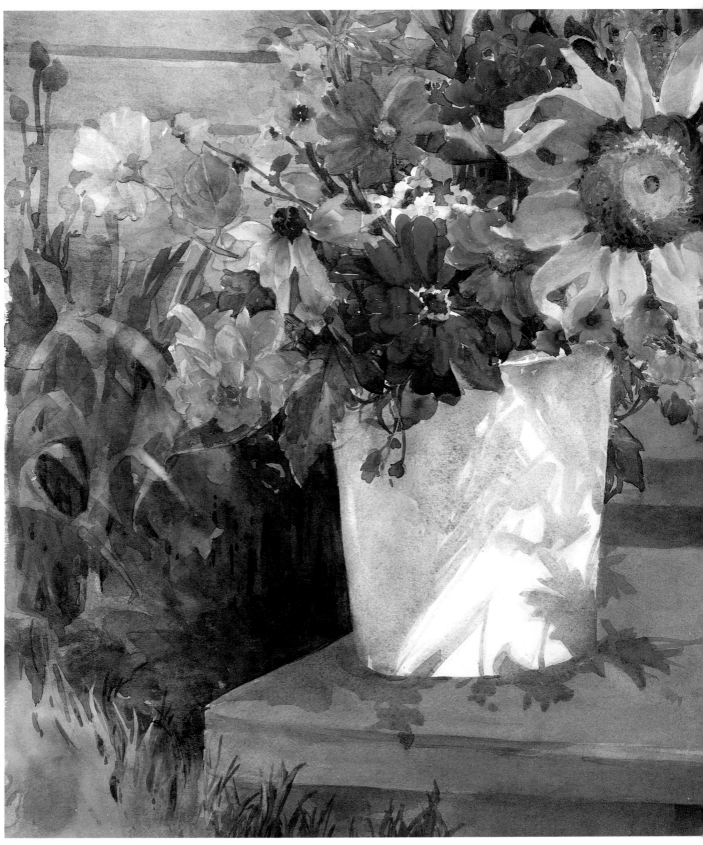

Basic Techniques

The process of learning to paint is similar to learning how to play a musical instrument in that both require patience as well as frequent and consistent practice. Also, building confidence and developing dexterity in either pursuit takes time and commitment. Gradually your mind, eye, and hand will begin to work in unison, but it won't happen overnight. Keep in mind that you don't have to perfect (or even complete) every painting you start. You can begin some paintings as "warm-ups," or even as experiments.

By following the sequence of exercises in this chapter, you will gradually become acquainted with your equipment as well as with the process of painting. You'll begin to think about your subjects in terms of their shapes by analyzing and simplifying complicated forms. The concept of value, which can be the most difficult hurdle for a beginning painter to surmount, is also discussed, and an exercise for painting a value chart is provided to help you improve your ability to see. Finally, I show that the color green, which many artists find particularly challenging, can be approached positively, with an attitude of experimentation.

DRAWING WITH A BRUSH

The watercolor painting technique of drawing with a brush can improve your work by producing more expressive, spontaneous forms and images. I ask my students at least to try renouncing their pencils and the somewhat rigid, dispassionate method of "filling in the lines." Note, however, that the technique of drawing with a brush doesn't exclude using a pencil to establish a composition's basic forms. I usually pencil in rectangular and/or oval shapes to indicate the basic framework of the image within the format of the painting. In more complex paintings I pencil in large shapes to identify general areas but refrain from establishing detail, as that can restrict the natural progression and development of a work.

BASIC STROKES: THE ROUND BRUSH

The round brush, which I use almost exclusively for laying down color, is my primary painting tool. The demonstration below shows a basic, all-purpose round brushstroke that I often use to paint leaves, which I call the double triangle. Another fundamental round brushstroke is the S stroke, which you can use to fill both large and small areas while achieving texture and variety of color.

As with any other skill, learning to use a brush and perfecting your strokes will take patience and practice. Keep in mind that I'm left handed (as you can see in the photographs below), so simply reverse what's shown if you're right handed.

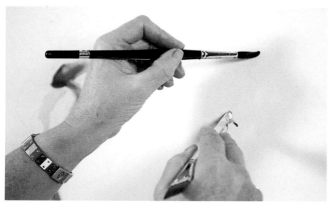

To make a double triangle stroke, hold a loaded brush about an inch above the ferrule. With a relaxed grip, hold the brush as you would a pencil just before you begin to write with it, but with a bit more flexibility. In your other hand, hold a flat brush upside down so that you can use its handle as a mahl stick. Alternatively, you may rest the palm of your hand directly on the paper.

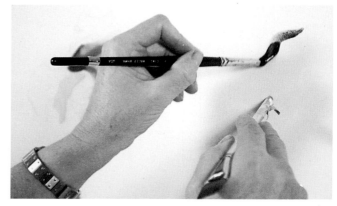

To begin the stroke, press the hairs or bristles down so that the ferrule is very close to the paper. This action creates the body of a leaf. As you approach the tip of the leaf, lift the brush.

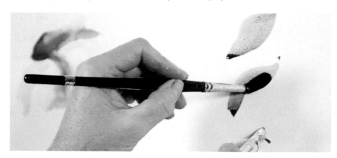

Return to the stem and repeat the previous step, overlapping the previous stroke.

To make an S stroke, repeat the first two steps for the double triangle, but this time work the bristles in a flat S or snake shape. Overlap the strokes and keep the brush on the surface of the paper to avoid leaving gaps or spaces. It may take a little time and practice to blend the right paint-to-water ratio for this stroke.

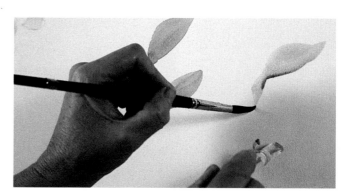

To create movement in the leaf, continue to press down, then bring the brush back up. This will create a triangle shape at the base of the leaf.

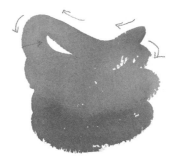

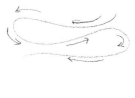

Basic Strokes: The Flat Brush

In addition to using it to support my left hand when I'm holding a round brush, I use the flat brush for several other important purposes, including:

- Wetting the paper

- Laying in large washes

- Softening edges

- Rendering floral and foliage shapes

Practicing the two flat brushstrokes shown below—the pie wedge and the line—will increase the flexibility of your wrist. I've found that synthetic brushes are better for these exercises than sables because they're somewhat stiff. It's essential that your flat brushes are in good condition or you'll end up with curved or zig-zag strokes. When I paint with a flat brush, I use a round brush as a mahl stick.

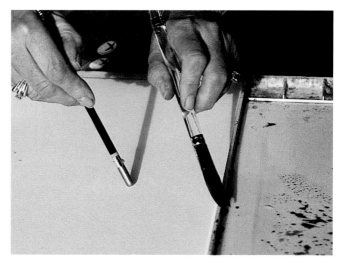

Before starting the pie wedge stroke, load your flat brush with paint, then wipe it across the lip of the palette to give it a straight edge.

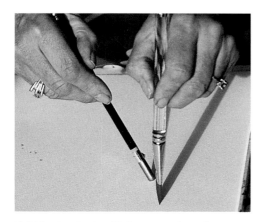
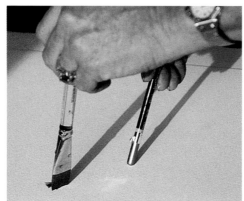
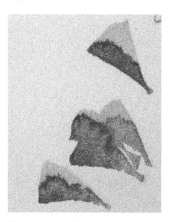

Hold the brush at a 45-degree angle to the paper at all times. (The photograph at left is a frontal view, and the photograph at right is a side view.) While keeping the end of the brush pointing toward you, press down and turn the tip a few degrees to create the triangle shape.

You can use the pie wedge stroke alone or in groupings to depict leaves.

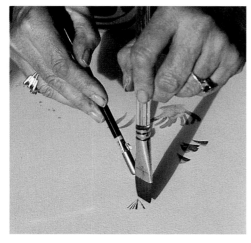

For the line stroke, follow the instructions for the pie wedge stroke, only this time lift up the brush as soon as you touch it to the paper.

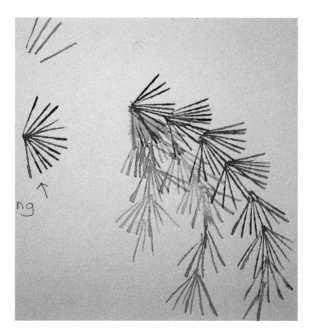

By repeating line strokes and connecting several at one end, you can create a cluster of pine needles. Group several clusters together to create a bough. This unadorned approach gives the arrangement an oriental feeling.

Using Both Round and Flat Brushes

I often use both round and flat brushes on the same areas in my paintings. For example, if an area in a painting is too dark in value and I want to lighten it—for example, to turn a petal or adjust its color—I simply pull color out with a damp flat brush to create a gradual transition.

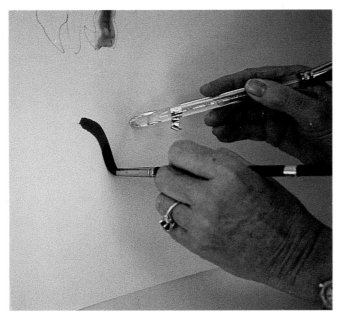

Load the round brush with paint. Using the flat brush as a mahl stick, hold the round brush by the ferrule and press down, working from the inside of the petal, lifting the brush as you reach the end.

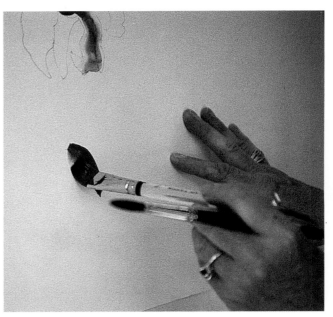

Immediately switch brushes (using the round brush as the mahl stick), then slightly overlap the edges of the form with a dampened flat brush. (It's important to act quickly, before a hard edge forms.) This is done to create a gradual progression of color, leading to a white edge.

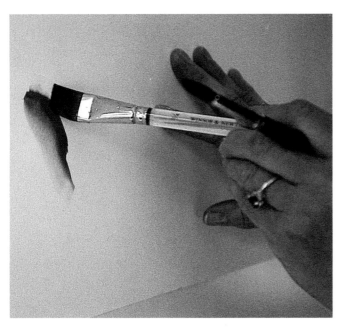

Repeat on the other side of the form.

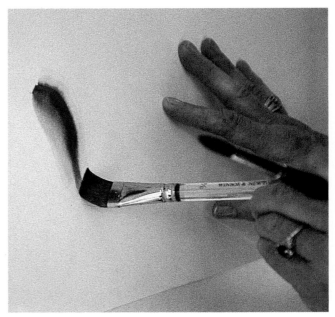

The final result: a turning of the edge of the leaf or petal that suggests depth.

SOFTENING EDGES

As you paint, you'll begin to notice that soft edges recede and hard edges advance within a composition. I soften edges by using a round brush and a flat brush almost simultaneously: I use a round brush to lay down the paint, and a damp flat brush to soften the stroke. I only use both brushes where I feel it's necessary, to create balance within and maintain the focus of the painting. A few of the situations for using the flat brush after paint has been applied are shown below.

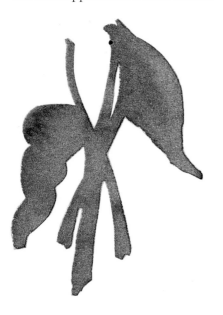
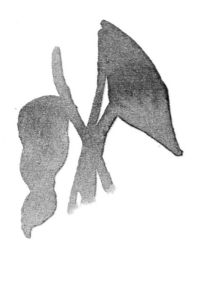

If a cluster or grouping has many stems or spaces between the stems, hard edges will develop when you stop working and the paint dries. This can cause a painting to look fragmented and broken, making it very difficult to pull together later (left). While the paint is still wet, use a flat brush to soften the edge where you plan to continue (right). This will enable you to pick up easily where you left off, either behind or on top of the established shapes.

Every so often you'll need to remove a hard edge after a painting has already dried. To do this, go over the edge with a damp flat brush, then blot it with a tissue. You can repeat this several times to achieve very subtle results. Note that only the bottom edge of the leaf shown above has been softened.

UNDERSTANDING VALUE

The term "value" refers to the relative lightness or darkness of a color as it relates to white, black, or the range of grays in between. A color is described as light, medium, or dark in value. The concept of value can be one of the most difficult for a beginning artist to understand and to "see," but a deliberate and knowledgeable use of value is essential for achieving depth and interest in a painting. When one of my paintings doesn't seem to be developing in a satisfactory direction, I first reevaluate the value relationships of its colors.

As an aid to understanding value, I still refer to a value chart that I made many years ago as a student. It's just the right size to fit in my sketchbook, so I always take it with me. I urge my students to make their own value charts, rather than buying a finished chart that was developed by another artist. The exercise of creating your own chart will give you invaluable insight into the concept of value, enabling you to apply the idea in practical terms.

To make a value chart, start by drawing nine 1 x 1½ inch rectangles on a piece of watercolor paper, then number them from 1 through 9. (If you prefer to work in a larger format you can increase their dimensions.) In the exercise below I used Payne's gray because it is a neutral color with a good value range, but you can also create a separate value chart for each color on your palette. The process of laying down progressive washes of color to indicate a full range of values is described in detail below.

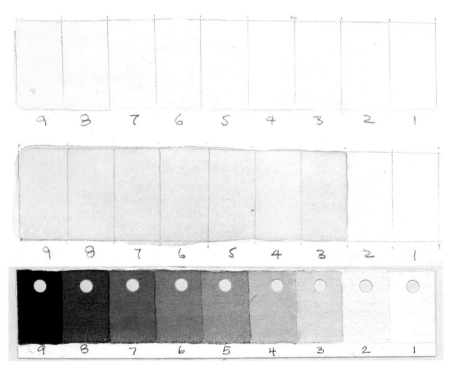

It's easiest to begin a value chart by first laying down the very lightest of washes, painting blocks 2 through 9 and leaving block 1 as the white of the paper. (Note that some artists prefer to number the value blocks starting with 1 at black. Both ways are acceptable.) Let the chart dry completely before adding the second wash.

Next, add just a little more color to blocks 3 through 9. Let dry, then add more color to blocks 4 through 9, and so on, until you paint only block 9 with the final wash. Each time you add a wash of color, the contrast between adjacent blocks should increase. When the chart is finished, block 9 should be black.

A completed value chart. I punched a hole in each block so that I could assess a color's value by simply laying the chart over the painting and matching the value through the hole.

This simple workshop demonstration illustrates how subtle changes in value and color can be used to create depth within a painting.

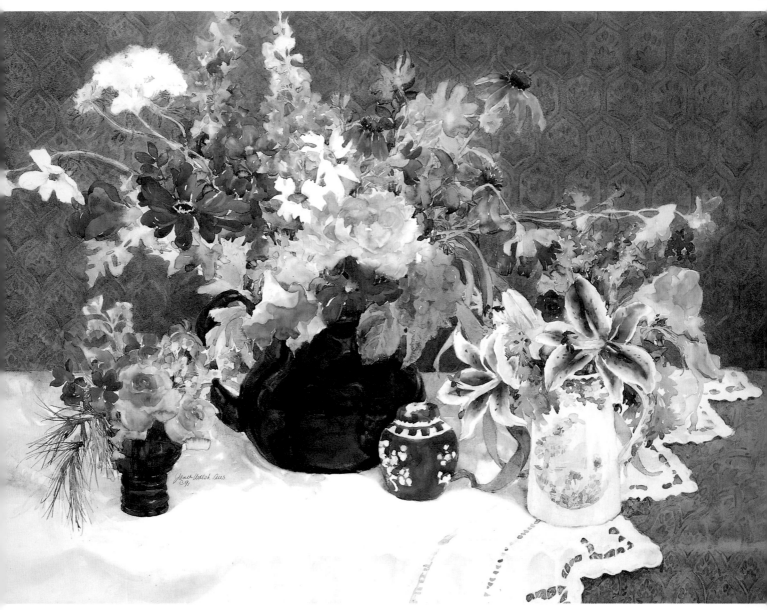

Blue on Blue #1
Watercolor on 300-lb. Lanaquarelle cold-pressed. 22 x 30 inches (55.9 x 76.2 cm).
Collection of the artist.

Value plays an important role in creating the mood of a painting and in dramatizing
the delicacy and strength of its floral forms. If you compare the various flowers,
you'll see a wide range of values, helping to create movement and interest. Note
that the subtle patterning in the blue cloth doesn't interfere or compete with the
bouquet because its design was painted within a three-value range.

Working with Greens

As you develop your painting skills, your knowledge about and preferences for certain colors will develop along with them, and gradually change as you gain experience. Some colors can be more difficult to master than others, and green can be particularly challenging, especially in depicting vibrant foliage within a still life.

Mixing Greens for Foliage

Because I want the foliage in my floral still lifes to act as a backdrop or supporting element for the brightly colored flowers, I tend to use muted or somewhat grayed greens. This should not imply that foliage is any less important in my paintings; on the contrary, it serves as a strategic counterpart to the flowers, and deserves equal consideration.

While none of the greens shown in the chart below is a "true" green—an equal mixture of blue and yellow—they work well for me. All artists have personal mixtures and preferences, and you will certainly develop your own. Experiment first by duplicating my mixtures, then try mixing another artist's, and then mix some of your own. You'll be pleasantly surprised at the results.

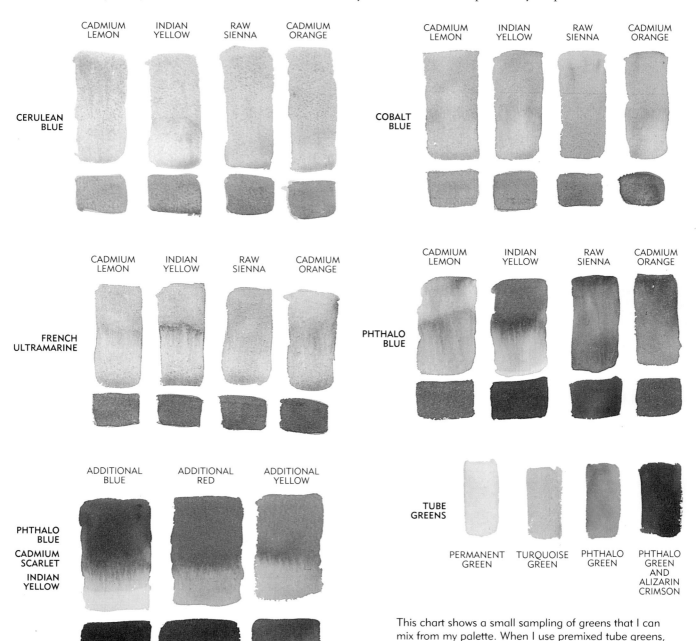

This chart shows a small sampling of greens that I can mix from my palette. When I use premixed tube greens, I usually neutralize them with orange or red. One of my favorite mixtures is phthalo green and alizarin crimson, which produces a beautiful black-green.

Simplifying Foliage Forms: Problems and Solutions

Foliage occurs in a limitless number of shapes, sizes, and hues of green. In most locations many examples are easily accessible. The countless assortment of shapes can be used to express many moods in a painting—energy, vigor, delicacy, and strength—and I try to express these sensations in my foliage. An effective way to make visual sense of the enormous variety that can be found in foliage is simply to practice painting it.

The elements of foliage can be painted in numerical groupings. For example, to paint natural-looking pine needles, cluster them in groupings of two, three, four, or more. If equal numbers of needles appear at regular intervals on both sides of the branch, the result is a static, unnatural look. Note also the variety of negative spacing in and around the leaves.

Varying size, shape, number, and color in your painting, particularly if you're a beginner, can be confusing. If you're having trouble, concentrate on painting large shapes by doubling or tripling the size of the leaf, which will make it easier to understand the brushstrokes that are involved in each form. Start by making several attempts, one focusing on color, another on shape, and a third on size. Then try to put them all together. This approach will take time and a willingness to make mistakes as you explore. However, the lessons you learn from these exercises will become a permanent part of your artistic repertoire.

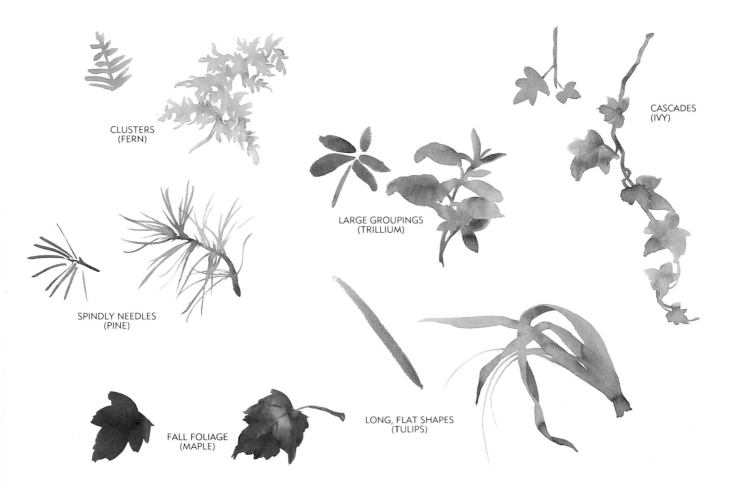

CLUSTERS
(FERN)

CASCADES
(IVY)

LARGE GROUPINGS
(TRILLIUM)

SPINDLY NEEDLES
(PINE)

FALL FOLIAGE
(MAPLE)

LONG, FLAT SHAPES
(TULIPS)

In the leaves shown at left, the colors are static, and the forms are straight, stiff, and generally lifeless and awkward. In addition, the hard edges undermine a sense of unity between stems and leaves. To avoid these problems, try: (1) varying sizes and shapes; (2) mixing the colors directly on paper rather than on the palette, which will result in a continuous variation of color; (3) bending contours and angles on stems, particularly those on pine and ivy; (4) exaggerating forms that are discernible through squinting; and (5) displaying movement in longer forms (for example, long thin leaves have a ribbonlike motion, while pine needles have a graceful subtlety).

DEMONSTRATION: ADDING FOLIAGE TO A BOUQUET

Now that I've given you a few suggestions on how to create a variety of green mixtures, doing this exercise is a good way to test them out. I often use it in my workshops when my students are struggling with foliage. If you feel that this particular lesson is too advanced for you, start with a very simple setup that includes only one or two stems, then gradually work on more complex arrangements.

I gathered a variety of greens for this demonstration from my garden.

After arranging the setup, I started the painting with the leaf above the geranium, followed by the geranium itself, then the dusty miller (the bluish green leaf immediately below the geranium). I then worked from left to right on the variegated leaves, remaining conscious at all times of the variety of greens and shapes. Here you can see the transition from one color green to the other.

Only the variegated leaves of the holly, which I treated the same as I would a white flower because of the white edges, required a light sketching-in with a pencil. I also used a pencil to indicate where I thought the container should be placed.

PALETTE

- CADMIUM LEMON
- INDIAN YELLOW
- ALIZARIN CRIMSON
- COBALT VIOLET
- COBALT BLUE
- PHTHALO BLUE
- CERULEAN BLUE

CLUSTERS AND GROUPINGS

Very often in nature, many small, busy forms appear in clusters. Clusters of color can make wonderful accents that add sparkle to a painting. I often like to pick wild berries from the woods that surround my studio and use them in my setups.

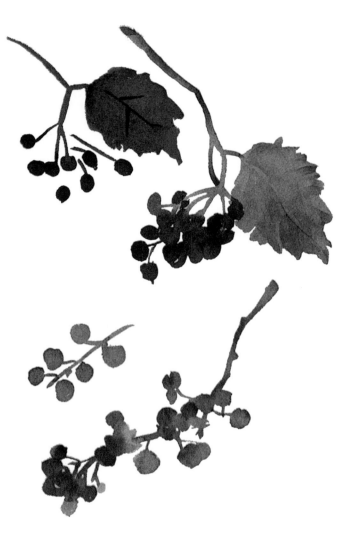

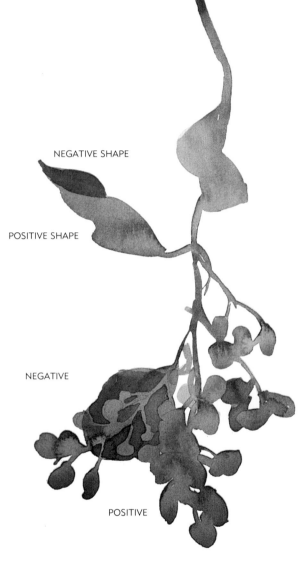

NEGATIVE SHAPE

POSITIVE SHAPE

NEGATIVE

POSITIVE

The examples on the left of each of these two sets of berries display some of the same shoitcomings that are reviewed in the foliage chart on page 35, including: (1) fragmented, stiff, and lifeless shapes; (2) bright green foliage that either conflicts with or dominates the color of the berries; and (3) an excess of symmetrical design, which lacks visual interest. As shown at right in each set, the process of painting these forms can be simplified by depicting them in clusters. I softened the greens to direct the focus toward the berries, and angled the stems in various shapes (convex, concave) to give them some vitality.

This grouping not only demonstrates how to paint berries on a stem, but also incorporates several leaves. Starting with the end of the stem, I once again varied its angles, as well as the colors and groupings of the berries to create interest. I added the leaves near the center of the stem at the same time. After the painting had dried, I painted in the negative space around the berries, pushing them forward and defining the leaf with the second wash. Using these techniques, I was able to produce an effective image using very little detail and a limited palette.

CHAPTER THREE

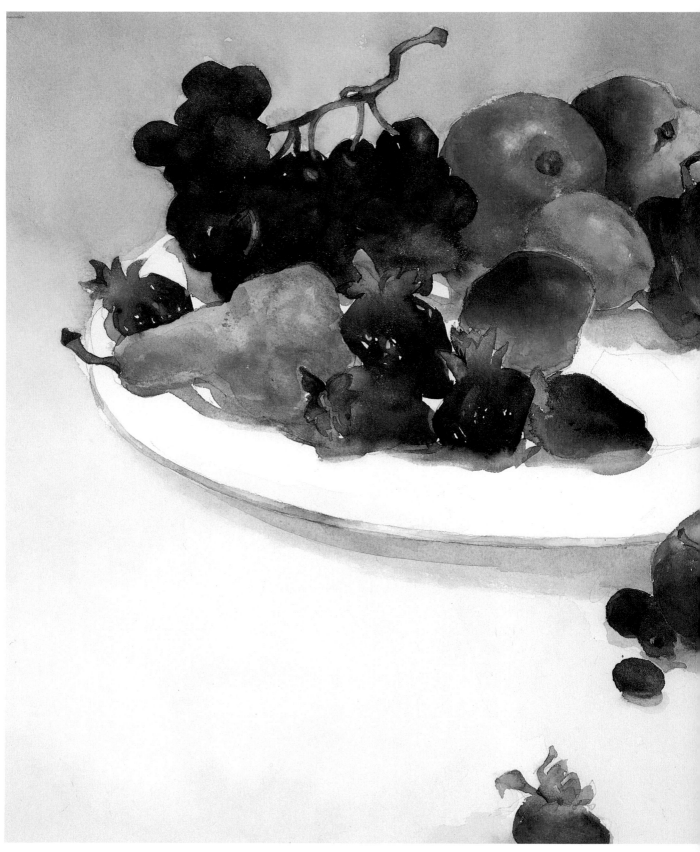

FRUIT PLATE
140-lb. Lanaquarelle cold-pressed. 22 x 30 inches (55.9 x 76.2 cm). Collection of the artist.

Painting Fruit

Painting fruit in still life compositions is a splendid way to explore the watercolor medium. Your "models" won't get restless and sometimes can last for weeks, although occasionally they'll begin to shrivel long before you've finished your painting. In spite of this potential hardship, the infinite variety of colors and the wonderful range of geometric shapes, from a simple lime to the more complex pineapple, can challenge the beginner as well as the experienced painter.

As we learned in the previous chapter, the basic method is to lay in color with a round brush, and immediately soften form with a dampened flat brush. Using this technique of edge shading, we work with washes of color—both flat and graded—in the two fundamental watercolor techniques: wet-in-wet (where the paper has been dampened and the artist, working quickly, periodically remoistens it) and dry-on-wet (where the paper is dry, and all subsequent washes are allowed to dry before work is continued).

LIMES

The basic shape of a lime is something of a cross between an oval and a circle.

This lime was painted with perfect symmetry, and its color shows very little variation. As a result, it lacks character and life.

If you look carefully you can see nuances of color within the skin of a lime. To create this particular green I mixed phthalo blue and Indian yellow together on the paper with a broad S stroke. I rinsed the brush and loaded it with thinned phthalo blue to add a cast shadow. Shadows can help keep an object from looking like it's floating in midair and by locating it in space and in relation to a light source. I then applied a second wash after the first had completely dried, intensifying the color. Finally, I added the stem.

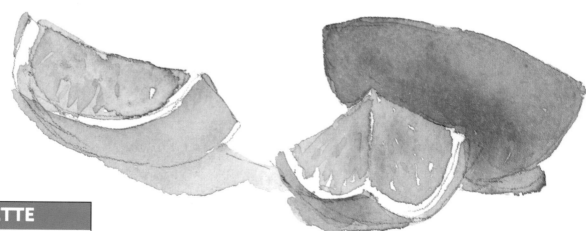

PALETTE

- CADMIUM LEMON
- INDIAN YELLOW
- CADMIUM ORANGE
- PHTHALO BLUE

Cutting fruit into shapes opens up endless design opportunities (see "Watermelons" on the opposite page). To create depth, I overlap circles, triangles, and ovals. Note the shadows, which I painted during the first wash to eliminate the need to soften edges.

WATERMELONS

A chunk of watermelon can be a fun way to explore watercolor. The intense color and the variety of shapes into which a watermelon can be cut are sure to stimulate your creativity.

Because I had planned to treat the seeds in two ways—painted in a dark brown and left as the white of the paper—I devised their placement ahead of time, covering them with White Mask to protect them from the color of the watermelon's flesh. Since watermelon seeds are not all the same size, shape, or color, I made careful decisions about their individual shapes as well as their groupings.

Starting at the top, I then painted both planes of the watermelon slice at the same time, moving from one side to the other. I used a damp flat brush to soften the edges where the red of the flesh meets the white and green of the rind, creating a soft blending of colors.

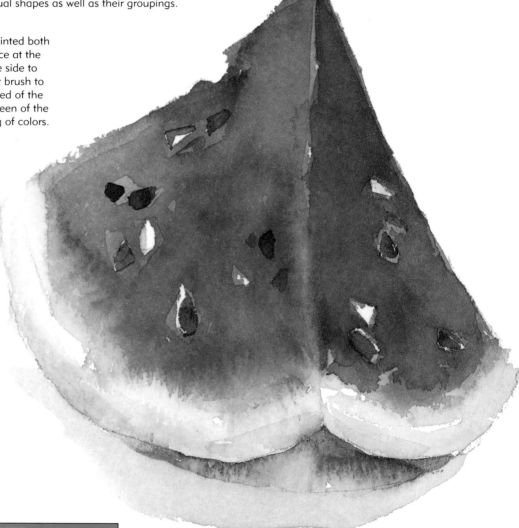

PALETTE

- INDIAN YELLOW
- WINSOR RED
- ALIZARIN CRIMSON
- PERMANENT ROSE
- WINSOR VIOLET
- PHTHALO BLUE
- PERMANENT GREEN LIGHT #1

Although the left side of the slice, which is comparatively warm, needed only one wash of color, the right side, which is cool, needed two washes. The second wash was pure alizarin crimson, which is a cool red, and I painted in the seeds after it had dried. Note the variations in the colors of the flesh, ranging from dark red to white.

PEARS

The shape of a pear is a little more complex than a lime's. If you look closely at a pear, you can see all sorts of angles and turns within its basic form.

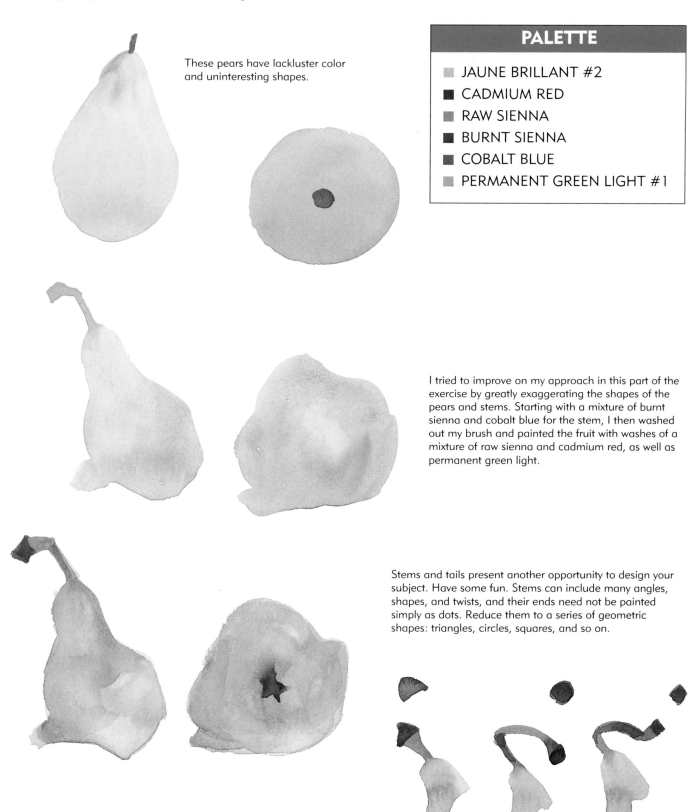

These pears have lackluster color and uninteresting shapes.

PALETTE

- JAUNE BRILLANT #2
- CADMIUM RED
- RAW SIENNA
- BURNT SIENNA
- COBALT BLUE
- PERMANENT GREEN LIGHT #1

I tried to improve on my approach in this part of the exercise by greatly exaggerating the shapes of the pears and stems. Starting with a mixture of burnt sienna and cobalt blue for the stem, I then washed out my brush and painted the fruit with washes of a mixture of raw sienna and cadmium red, as well as permanent green light.

Stems and tails present another opportunity to design your subject. Have some fun. Stems can include many angles, shapes, and twists, and their ends need not be painted simply as dots. Reduce them to a series of geometric shapes: triangles, circles, squares, and so on.

APPLES

When painting apples, I try to project the shine of their red skin while working to establish a smooth transition between red and green. I concentrate on the contours of the apples as I roughly draw in their basic forms.

In this instance I applied the red first, then rinsed the brush and added permanent green light, making sure that I overlapped the last stroke of red. When I finished adding in the green area I rinsed the brush again, then loaded it with more red pigment.

I used the S stroke at this point to ensure smoothness of application and to establish the shiny look of the skin. I then let the paint dry.

When painting two separate elements such as the apple and its stem, I try to think of them as a single shape, changing color as I proceed.

My last task was to lift out highlights by using a dampened scrubber, which also served to emphasize the planes of the apple.

As I worked I intensified color as needed throughout. So that the addition of color would be subtle and soft-edged, I dashed in some alizarin crimson to suggest roundness while the paint was still wet.

Painting negative shapes on either side of the stem during the second wash creates the illusion that the stem is attached to the apple.

The negative shape painted on the top left side of the slice gives it a sense of separation from the apple. All that's needed to separate the two forms is a hint of a space between them.

PALETTE

- CADMIUM RED
- WINSOR RED
- ALIZARIN CRIMSON
- PERMANENT ROSE
- BURNT SIENNA
- COBALT VIOLET
- PERMANENT GREEN LIGHT #1

BLUEBERRIES AND GRAPES

As is mentioned in the previous chapter, objects of the same size and color can be monotonous to paint and result in a stale composition, but this kind of exercise can also provide a good way for you to challenge yourself. Blueberries and grapes are both good examples of recurring similar fruit shapes.

These blueberries, all of which are the same size and color, seem dull and lifeless. In addition, because they all look exactly alike there is no focal point to their grouping.

PALETTE

- ■ ALIZARIN CRIMSON
- ■ COBALT BLUE
- ■ PHTHALO BLUE
- ■ PAYNE'S GRAY

In this study I varied the colors, sizes, and values of the berries, and modified the composition by grouping them in sets of two, three, and four. I painted some of the overlapping berries as a single shape. After the first wash dried I applied a few minor touches of color.

Here I painted the grapes just as I saw them, with each grape a separate entity. Like the blueberries above (left side), they all look alike and, as a result, are uninteresting. The stems don't lend a realistic feel to the grapes at all, and instead make them look like stiff lollipops. It's very difficult to combine single grapes into a group after the edges have dried.

I've combined the grapes in this study into a single bunch, but it's hampered by the halo effect created by the interaction of the outline of the grapes and a flat center of color.

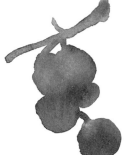

When painting a bunch of grapes, start with the stem, then let some of its color run into the grapes as you vary their size and color.

PALETTE

- ■ CADMIUM ORANGE
- ■ WINSOR RED
- ■ ALIZARIN CRIMSON
- ■ BURNT UMBER
- ■ WINSOR VIOLET
- ■ COBALT BLUE

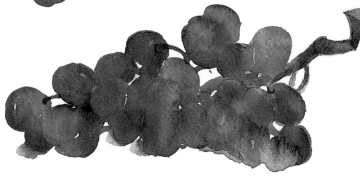

I painted this bunch of grapes with practically one wash, creating depth and interest only by making changes in color and value. I applied only one or two accents after the paint dried. Note the A shapes of the delicate branches of the stem. Even though I observed highlights in most of the grapes, I didn't feel compelled to paint them all.

KUMQUATS

Whether you're painting an individual piece of fruit or a grouping, it's important to treat the entire subject as a single entity. That is, while you're breaking down an object into shapes mentally, you are continually evaluating the relationship of each one to those immediately adjacent, as well as to the entire arrangement. Otherwise, the task of pulling all the pieces together becomes difficult, if not impossible, to accomplish.

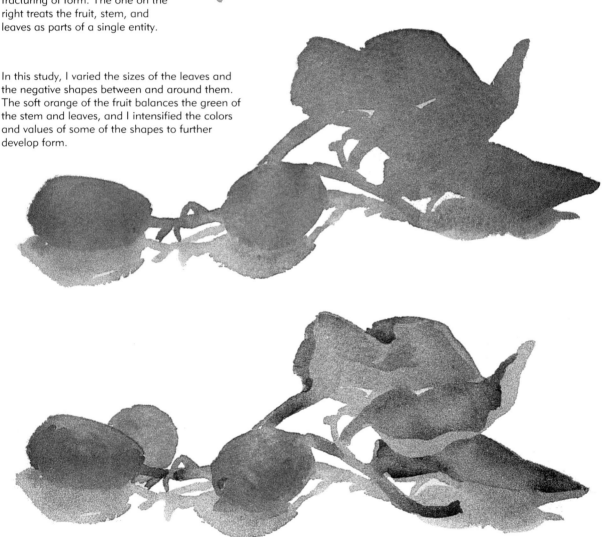

The study on the left looks fragmented and lifeless, due to a fracturing of form. The one on the right treats the fruit, stem, and leaves as parts of a single entity.

In this study, I varied the sizes of the leaves and the negative shapes between and around them. The soft orange of the fruit balances the green of the stem and leaves, and I intensified the colors and values of some of the shapes to further develop form.

As finishing touches, I added just a suggestion of highlights as well as an overlapping third kumquat to keep the arrangement from looking too balanced. The final result: a variety of shapes, values, and edge textures.

BANANAS

Bananas serve to illustrate groupings of fruit that are composed of large, somewhat awkward shapes. They are similar to blueberries and grapes in their uniform coloration. When painting any kind of grouping, it's important to strive for an interesting overall shape. To accomplish this it may be necessary to distort the shape of the fruit somewhat, by either stretching or compressing it, or twisting it so that a slightly different aspect of it is highlighted.

I first roughly sketched an outline. Yellow can be difficult to work with, as it doesn't have the value range of most other colors, and there's a tendency for it to look opaque even after the first wash. I try to vary the yellows in my paintings by using more than one at a time. Here I added a touch of jaune brillant to soften the cadmium lemon. Thinning the mixture with water will also keep color transparent, and using the S stroke can produce variation.

After the first wash had dried, I very carefully (and selectively) painted in some negative shapes with cobalt violet and Winsor violet. Remember: Less is best.

PALETTE

- CADMIUM LEMON
- JAUNE BRILLANT #2
- CADMIUM ORANGE
- BURNT SIENNA
- COBALT VIOLET
- WINSOR VIOLET
- PERMANENT GREEN LIGHT #1

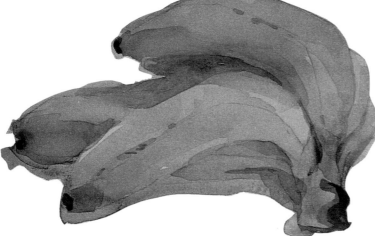

In general, it's best to keep details to a minimum. By adding cobalt violet, I created the impression of reflected light beneath the banana. I varied the colors of the darker-value negative shapes at each end so that they wouldn't seem like bland afterthoughts.

PINEAPPLES

With an elaborate network of leaves sprouting from its top and a heavily patterned husk, the pineapple is one of the most difficult fruits to render effectively in watercolor.

When you first try painting a pineapple, avoid making the top and bottom, as well as each leaf, the same size. Squinting to simplify form is particularly important when painting a complex object such as this.

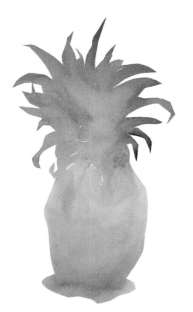

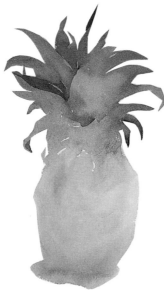

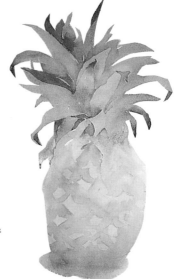

First I made a pencil sketch indicating the relationship of foliage to fruit. I knew if I drew in every leaf the energy of the painting would be jeopardized. As I started painting the leaves using the S stroke, I exaggerated their shapes—some plump, some light, some dark—and let colors run together to create texture.

After I finished the foliage, I cleaned the round brush and continued with the husk, establishing value and color variations. As always, I lay in color with the round brush and immediately soften edges with the flat brush to prevent hard edges from forming.

I then further defined the foliage by adding more shapes, values, and colors. I applied a second wash to the body following the pattern sketched at right to form triangles and hexagons. I used more Indian yellow on the left, gradually shifting to cadmium orange as I worked toward the right to create a strongly textured pattern without extremely hard edges. This kind of modeling—employing changes in color and light and shade—creates movement and form.

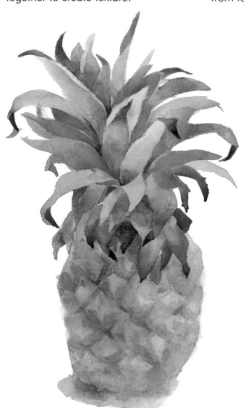

In this study, I focused more intently on the foliage than on the fruit, accentuating its height and using a variety of colors and values to create the effect of depth.

PALETTE

- CADMIUM LEMON
- INDIAN YELLOW
- CADMIUM ORANGE
- CADMIUM SCARLET
- PERMANENT ROSE
- RAW SIENNA
- WINSOR VIOLET
- COBALT BLUE
- PHTHALO BLUE
- CERULEAN BLUE
- COBALT TURQUOISE
- PERMANENT GREEN LIGHT #1

CHAPTER FOUR

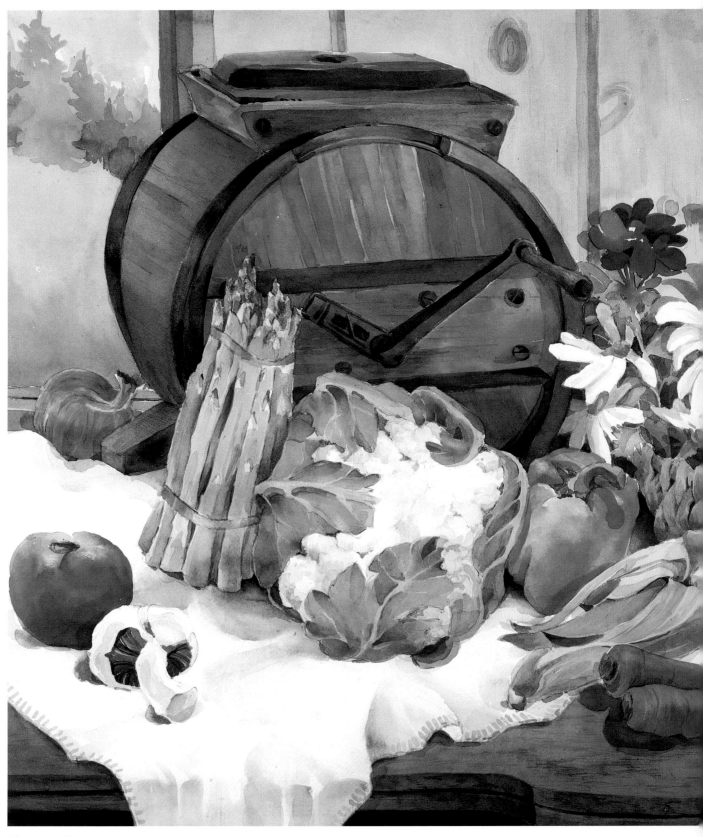

COUNTRY BUTTER
Watercolor on 140-lb. Arches cold-pressed. 22 x 30 inches (55.9 x 76.2 cm).
Collection of Molly and Phil Michael, Tavenier, Florida.

Painting Vegetables

The techniques for painting vegetables in watercolor are generally the same as those for painting fruits, making some of the techniques that are discussed in the previous chapter applicable to the forms presented in this one. There are, however, certain features unique to vegetables that require special consideration. One important difference is that many vegetables have contiguous leaf forms, making them an ideal painting and sketching intermediary between fruits and flowers. Also, vegetables generally require more contour development than fruits, which gives the beginning painter an opportunity to develop a level of proficiency in a skill that is essential for painting successful still lifes as well as other genre.

In this chapter, nine vegetable forms are reviewed: onions, carrots, radishes, Indian corn, cabbage, red potatoes, red peppers, cauliflower, and broccoli. Included at the end of the chapter is a step-by-step demonstration showing the development of a painting, from the setup of the various elements as a composition to the completed work. By studying and painting the specific physical characteristics of a wide variety of vegetable forms, a beginning painter can quickly widen the horizon of his or her artistic experience.

ONIONS

An onion is shaped like a circle, with a "head" and a "tail." Add subtle color changes that you observe only after you've established the basic shape.

Start the onion at the head and end with the tail. Eliminate details at first by squinting, then paint the shape.

To portray complicated value shapes, I simplify the form by placing a sheet of tracing paper over the first wash, then sketch in some details with a pencil. I evaluate the results, make any necessary adjustments on the tracing (if I don't like what I've done I might make another), then continue painting, using the tracing paper pattern as a guide. Although I sometimes transfer my tracings directly to the painting, keep in mind that it's much easier to make changes on a tracing than it is on watercolor paper.

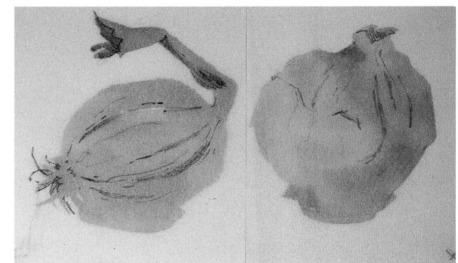

The heads and tails of onions can be twisted and turned in an endless number of possible configurations. In addition, the contours of the bulb can be made heavier, thinner, longer, or shorter.

PALETTE

- INDIAN YELLOW
- PERMANENT ROSE
- RAW SIENNA
- BURNT UMBER
- COBALT VIOLET
- COBALT BLUE

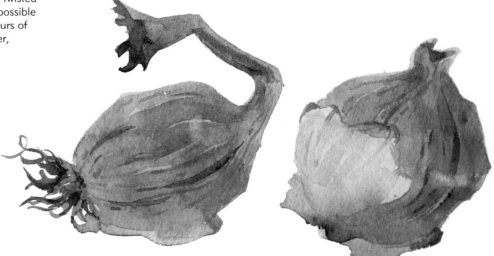

CARROTS

Carrots generally have a simple cone shape that is often depicted stiffly and awkwardly. Note, however, that many variations and nuances can be found within the standard shape.

I began the carrot with the foliage, then continued with the root. I let the colors of the two flow together on the paper, which made the carrot look more realistic. I let the painting dry before applying the second wash.

The second wash exaggerated and defined areas and intensified the color. I also indicated some negative shapes in the foliage, but chose not to paint every detail.

RADISHES

Radishes are particularly interesting to paint, as they combine techniques that are used to paint both fruits and vegetables and require overlapping and varying shapes, sizes, and colors.

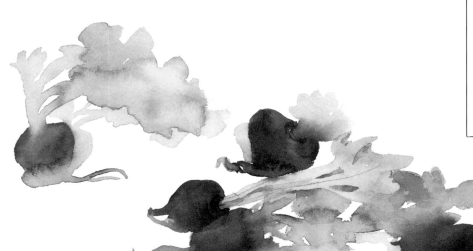

I develop soft edges, which are sometimes called *linkage*, by moving quickly from one shape to another. I tone down the greens to accent the red/purple mixtures. Note the several distinct shapes that compose the vegetables: Triangles, hearts, and ovals all overlap to create depth of form. The radish on the far left has only one layer of wash. Color variation occurred as I worked from the ends of the greens through each radish.

INDIAN CORN

With its varied texture and many small kernel forms, Indian corn is a complex subject that you should try not to overwork. Try to remember that the cylinder is its underlying shape, and that if you establish it successfully it will serve as a good foundation for your painting.

I approach Indian corn in the same way as I do onions (see page 50). Starting with the ear, I paint from right to left. I at first disregard the many layers of the husk and try instead to capture an overall flat shape, along with some of the nuances of color.

Tracing paper is essential in developing the details within the corn without overcomplicating it. When I place the tracing paper over the first wash, the form is immediately simplified. I then pencil in some value shapes, as well as some specific features. Using the tracing as a guide, I continue to paint, occasionally transferring pencil marks lightly onto the watercolor paper.

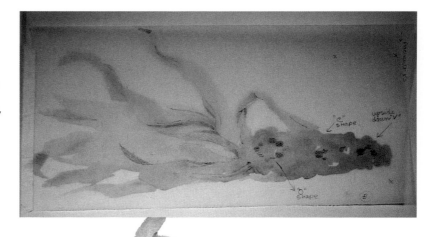

PALETTE

- JAUNE BRILLANT #2
- INDIAN YELLOW
- CADMIUM ORANGE
- RAW SIENNA
- PERMANENT MAGENTA
- WINSOR VIOLET

At this stage, I exaggerate the rhythm of the husk by painting in letterforms—such as Vs, Os, and Cs—for kernel patterns. Again, don't overdo it. A little goes a long way!

CABBAGE

With the bounty of produce that's available, a visit to a farmer's market in the fall can be an especially delightful experience. I'm always drawn to the gigantic cabbages, with their large leaves and subtle colors. When I decided to paint one during a recent workshop, I had great fun showing my students how to tackle a painting exercise that can teach volumes about the concept of value and the many colors of green.

Before I start painting a subject that is as subtly colored as this, I lay out all the colors I think I need. I don't mix them, though; I just arrange puddles of individual colors on my palette.

Next I make a rough sketch of the cabbage's outline, exaggerating its angles somewhat. Starting at the top of the form and working my brush in an S stroke (from right to left), I alternate between Indian yellow, phthalo blue, and a mixture of the two, then quickly change to permanent magenta, Indian yellow, and cobalt violet as I proceed. (Note the light yellow in the center of the cabbage.) I work quickly so that the paint won't start to dry, and clean the brush thoroughly whenever I change colors so that they won't become muddy, either on the paper or in my brush. The soft, gradual color changes that result introduce texture.

After the first wash dries, I work a bit more slowly. I begin to form leaves by laying down rich color with a round brush, then I use a dampened flat brush to soften the edges of the leaves so that they will turn.

To further define form, I continue painting both positive and negative shapes. Working very slowly, I add some leaf veins and other details, and use a change in value or color on each leaf to create depth.

PALETTE

- INDIAN YELLOW
- CADMIUM ORANGE
- RAW SIENNA
- PERMANENT MAGENTA
- COBALT VIOLET
- PHTHALO BLUE
- CERULEAN BLUE

RED POTATOES

The fun thing about painting potatoes is that you can make their underlying shapes as lumpy and bumpy as you want.

After mixing raw umber and permanent magenta directly on the paper, the potato at this stage looks one-dimensional. The color and texture are just right, though; mixing raw umber, which is semi-opaque, with a transparent color results in a smooth but dull texture. To create the impression of roundness I then make subtle additions and changes in color and value so that I can maintain the matte finish of the first wash.

Using permanent magenta and cobalt blue, I intensify color here and there to develop form.

These changes in value create the illusion of reflected light.

Working very delicately, I add the eyes last. Rather than a series of dark dots, they should only appear as suggestions of color and be very carefully grouped.

RED PEPPERS

The red pepper is the only vegetable whose contiguous green form (a stem) I paint as a separate entity. I do this because of the stem's position (it's in the center of the pepper), and because I like to exaggerate its contours as I work.

I first lightly draw in my shapes, focusing in particular on their angles and curves. Then I apply the first wash. Because this color is so intense, I reduce its value somewhat by mixing alizarin crimson, permanent rose, and Winsor red. The color variations that result also give the shape of the pepper some vitality. Before working on the stem, I soften the edges around its base.

The first wash for the stem is a mid-value mixture of phthalo blue and Indian yellow. Note the slightly exaggerated shape at the stem's end, where I intensified values to emphasize foreshortening. After modeling the pepper a little further, I selectively lifted out some highlights.

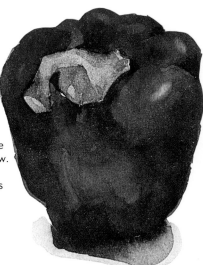

CAULIFLOWER

The cauliflower is a bit more complex than some of the other vegetable forms, so it requires a little more effort and planning. The basic shape of the white florets is a circle, with a border of green foliage surrounding it.

Rather than painting everything you see, painting only suggestions of shape within this complex form will help make your work more interesting and less labored. Remember that the florets are oval-shaped, but try to avoid repeating them monotonously by occasionally distorting their angles.

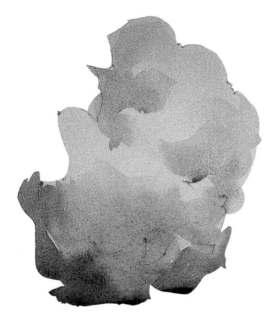

For the white of the florets, I apply thinned cobalt violet, Indian yellow, permanent rose, and cerulean blue in circles or ovals, taking care not to overpaint them by leaving some of the white of the paper visible.

I then paint the foliage, varying the colors and angles of the leaves and carefully choosing which edges to soften and which to leave hard. The resulting forms and shapes enhance those of the florets.

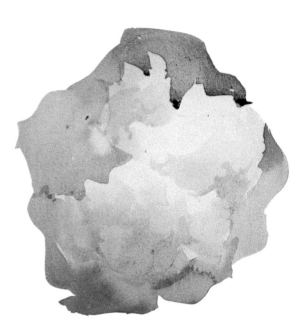

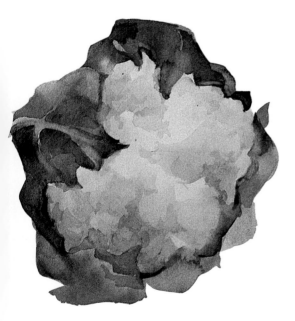

I return to the florets, selectively stroking in more circles and ovals. To increase value contrast and enhance the forms of the leaves, I add some permanent rose, cerulean blue, and cobalt turquoise. You might also consider exaggerating the colors in the foliage even further, perhaps by using higher-contrast violets, reds, and blues.

PALETTE

- INDIAN YELLOW
- PERMANENT ROSE
- RAW SIENNA
- COBALT VIOLET
- PHTHALO BLUE
- CERULEAN BLUE
- COBALT TURQUOISE
- PERMANENT GREEN LIGHT #1

BROCCOLI

Broccoli blends the dominant features of two other vegetables reviewed in this chapter: Like the cabbage, it can serve as a crash course in the color green, and its many tiny florets are similar to those in cauliflower. Seen from the front, the florets in a stalk of broccoli are circular, but from the side they look more oval. When you're ready to try painting a two-subject setup, you might try combining a broccoli stalk with a red pepper for maximum contrast in complementary color and rough and smooth textures.

Starting from the left, I concentrate first on establishing an irregular outside edge. I mix my colors directly on the paper, which immediately creates texture and interest. Note the subtle value changes where the florets and the stems meet.

I enhance the texture of florets with a small natural sponge. I dip it into one of the various puddles of colors I'm working with, then lightly press in color here and there, leaving some areas as is. Take care not to overdo it—sponged in color can quickly become too much of a good thing.

In the final stage, I add some definition and value shapes throughout the stem.

PALETTE
▮ INDIAN YELLOW
▮ PERMANENT ROSE
▮ RAW SIENNA
▮ PHTHALO BLUE
▮ CERULEAN BLUE
▮ PERMANENT GREEN LIGHT #1

DEMONSTRATION: HEADS 'N' TAILS

Rather than presenting each demonstration as a smooth, continuous sequence of steps, I think it's important that beginning painters be exposed to what is undeniably a challenging process. Despite the frustration that developing your painting skills can produce, you can take refuge from creative storms in the fact that artistic growth and a deeper understanding of the painting process are your guaranteed rewards. Although at times my journey through this process yields unsatisfactory results, I know that the experience I've gained through trial and error is invaluable.

When you compare the finished painting (see pages 58–59) to the composition photograph (right), note that I eliminated and rearranged some of the elements as the painting progressed, and that I used the entire palette in this work (see page 12).

For this painting, I arranged some of the vegetables in a widely arcing semicircle, and others in groups in which the forms overlapped. I chose a patterned fabric because the squares in its design helped pull the painting together, and provided good contrast with the round shapes of the vegetables.

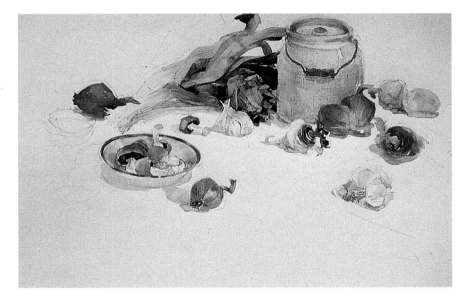

In a complex setup such as this, I begin by sketching only very simplified shapes; with the exception of the whites, I try not to focus too much on detail. I then lay in the first wash for all the vegetables and the crock, but I waited to work on the cloth separately.

After I had established the vegetable forms, I lightly sketched in the pattern of the fabric, then painted it.

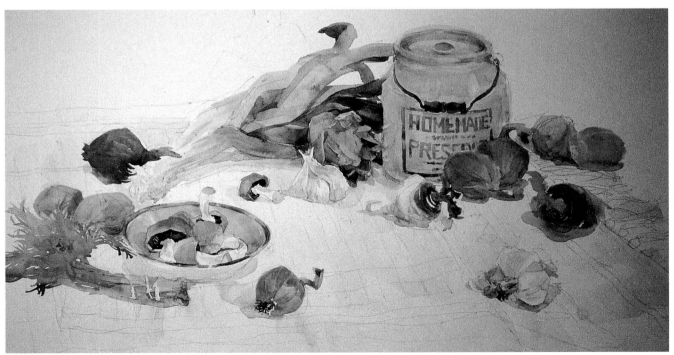

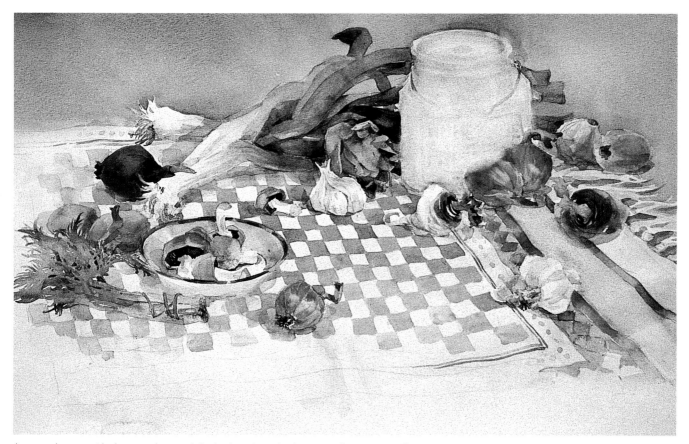

I was unhappy with the way the crock looked, so I washed it out with a sponge. On impulse I added a dark background, but unfortunately dark backgrounds don't always work. This one at first seemed much too dark and dreary and didn't complement the color of the arrangement.

After repainting the crock, I realized that the values and colors of the fabric and background were all wrong. I washed them both out with a natural sponge, taking care not to remove them completely.

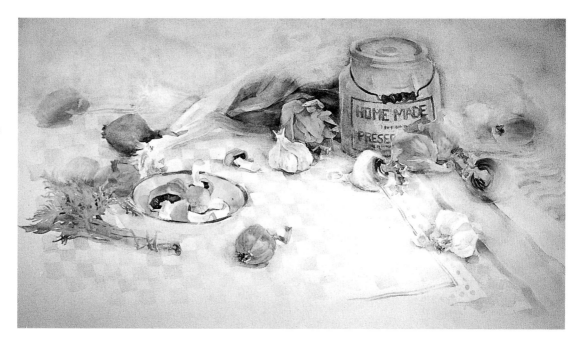

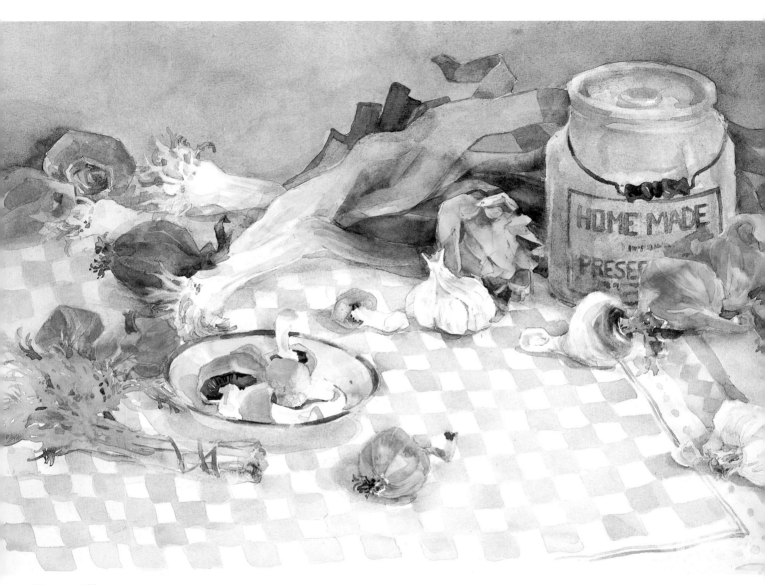

Heads 'n' Tails
Watercolor on 140-lb. Arches cold-pressed. 22 x 30 inches (55.9 x 76.2 cm).
Collection of the artist.

I painted the fabric in lighter-value, somewhat grayed colors so that it
wouldn't compete with or overpower the vegetables. I then added some
texture to the background (notice the warm-to-cool color change).

CHAPTER FIVE

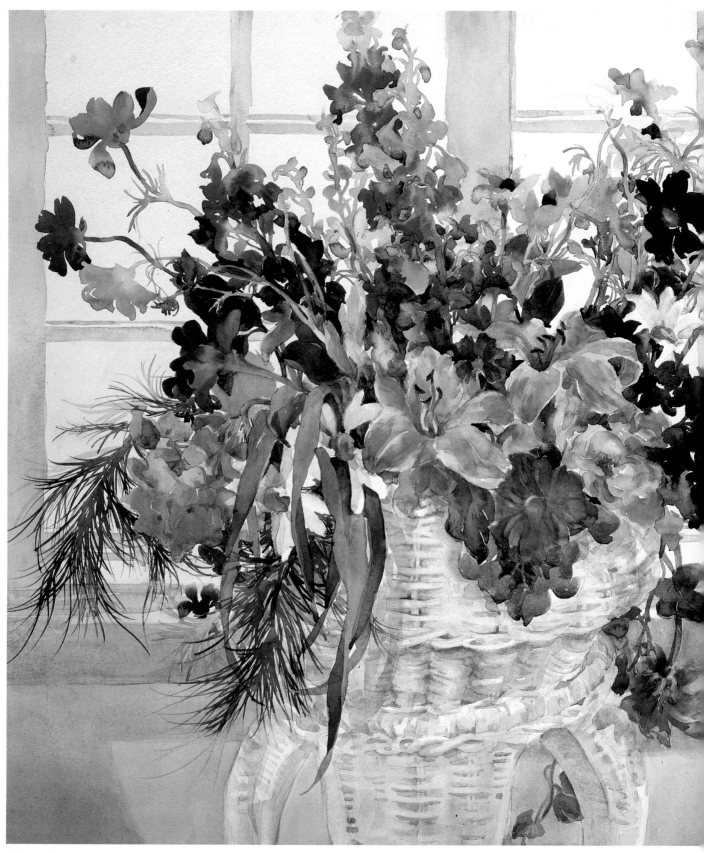

WHITE WICKER BOUNTY
Watercolor on 140-lb. Arches cold-pressed. 22 x 30 inches (55.9 x 76.2 cm). Private collection.

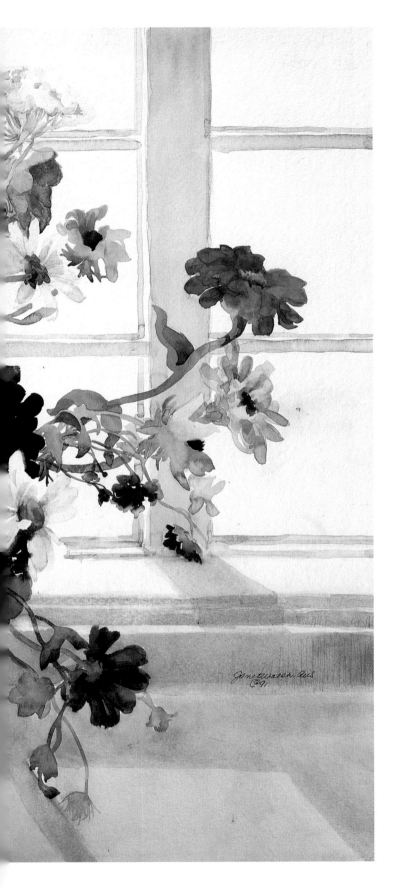

Painting Flowers

Painting a mixed bouquet of spring flowers, with its complex shapes, colors, and patterns, can be an intimidating task for a beginning watercolorist. A limited time frame can easily increase stress, as many varieties of flowers have extremely short life spans, making it difficult for an artist to work on a single arrangement for more than a few days.

When I begin to paint a bouquet or arrangement of flowers, I first look for interesting patterns and shapes. Rather than concentrating on correctly matching leaves and flowers, my first priority is to determine which shapes complement each other best.

For a beginner, an even easier approach is to break each flower down into its basic elements, instead of trying to paint every petal, stamen, and leaf vein. (A general rule of thumb: If you can't see it when you squint, don't paint it, or paint only your first impression.) I find that when my students can recognize and depict the distinct components of a flower, leaf, or fruit, they are more comfortable with the idea of simplifying form. Rather than fostering a botanical approach, the purpose of painting a flower's distinct elements is to provide a student with a more accurate idea of how it should be painted in its entirety.

Simplifying Floral Forms

My personal approach to painting flowers, either separately or in a complex arrangement, is to capture the "personality" of each bloom and to express my response to it through the energy of my brushwork and my delight in its colors. Seen at right are groupings of forms that, while painted very simply, suggest clearly identifiable flowers and foliage.

As your painting skills develop, continue to challenge yourself by moving from simple to complex setups. Always re-evaluate your choices as you work, keeping in mind that the elements of the composition—the objects (and their arrangement), lighting, and angle of view—can all be adjusted or changed at any point.

These examples show how to depict a range of flowers in a series of very basic shapes. Among those represented: tulips, daffodils, morning glories, and daisies.

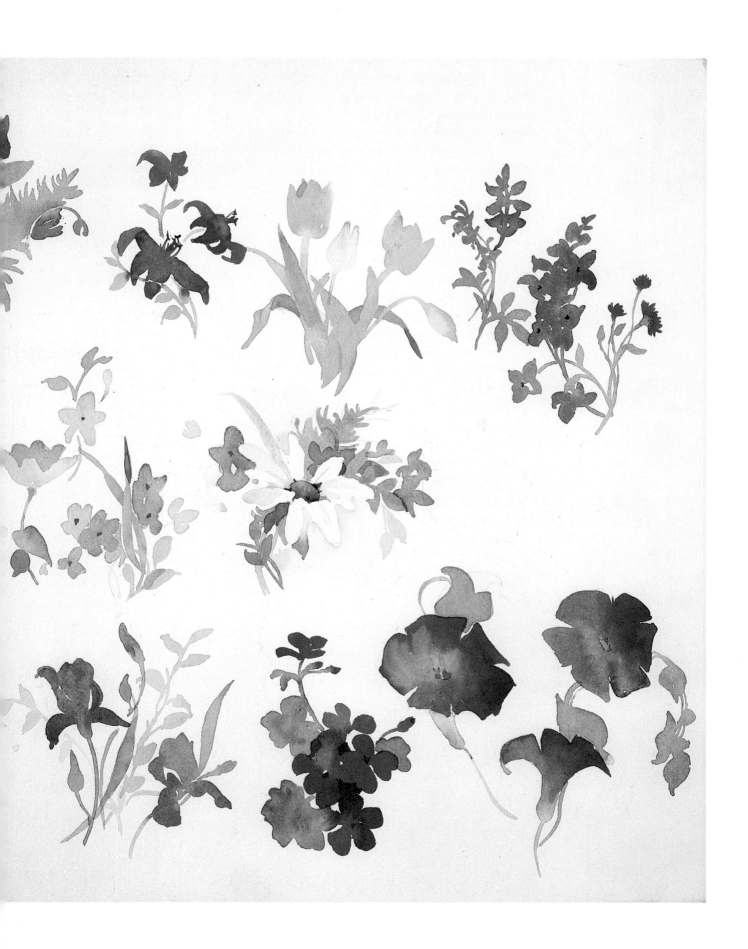

STATICE

The tufted flowers of the statice consist of a series of small V shapes (see "Basic Strokes: The Flat Brush," page 29, for a review of the pie wedge stroke). The stems are long and flattened and have very few leaves. Statice are very long-lasting—they'll almost surely outlive the rest of whatever bouquet they're a part of—and dry well.

The principal shapes of a statice: petals, calyx, stem, and leaves.

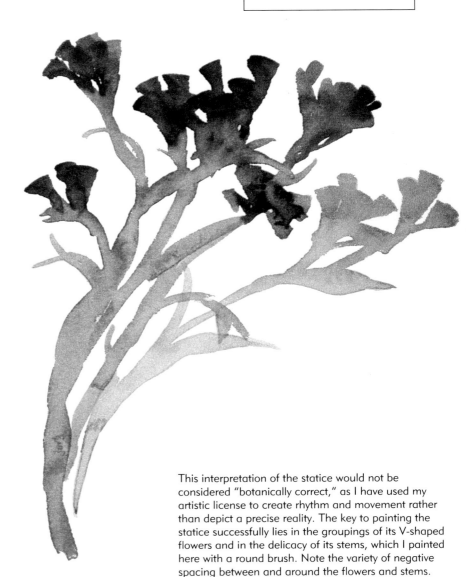

To avoid making this somewhat rigid flower look even more so, paint the calyx and start of the stem immediately after painting the flower, before its paint has dried.

This interpretation of the statice would not be considered "botanically correct," as I have used my artistic license to create rhythm and movement rather than depict a precise reality. The key to painting the statice successfully lies in the groupings of its V-shaped flowers and in the delicacy of its stems, which I painted here with a round brush. Note the variety of negative spacing between and around the flowers and stems.

CARNATIONS

With their sturdy good looks and availability in a wide range of colors and sizes, carnations are a good choice for almost any bouquet, either massed together or combined with other flowers. When they are first purchased from a florist, carnations often have very tight buds and flowers. As they open, a greater variety of texture and shape can be seen in the edges of their petals.

The principal shapes of a carnation: bloom, calyx, stem, and leaves.

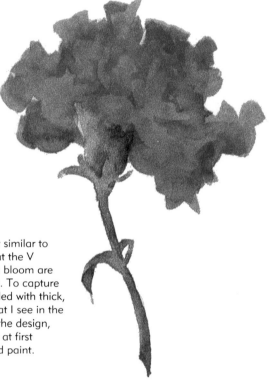

I paint carnations in a manner very similar to the one I use for statice, except that the V shapes that comprise a carnation's bloom are larger and arranged in a half circle. To capture their texture, I use a flat brush loaded with thick, juicy paint. I instinctively adjust what I see in the flower itself to get the most out of the design, and discount the soft texture that's at first created by the mixture of water and paint.

After the first wash has dried, I continue to add definition here and there, making sure to soften some edges as I proceed.

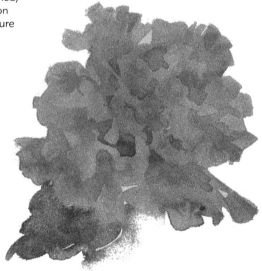

PALETTE

- JAUNE BRILLANT #2
- INDIAN YELLOW
- CADMIUM RED
- PERMANENT ROSE
- RAW SIENNA
- WINSOR VIOLET
- PHTHALO BLUE

Cosmos

A cosmos is a good flower for a beginning painter to start with. Its gentle circular bloom is perched on a thin, delicate stem that often winds its way through a bouquet.

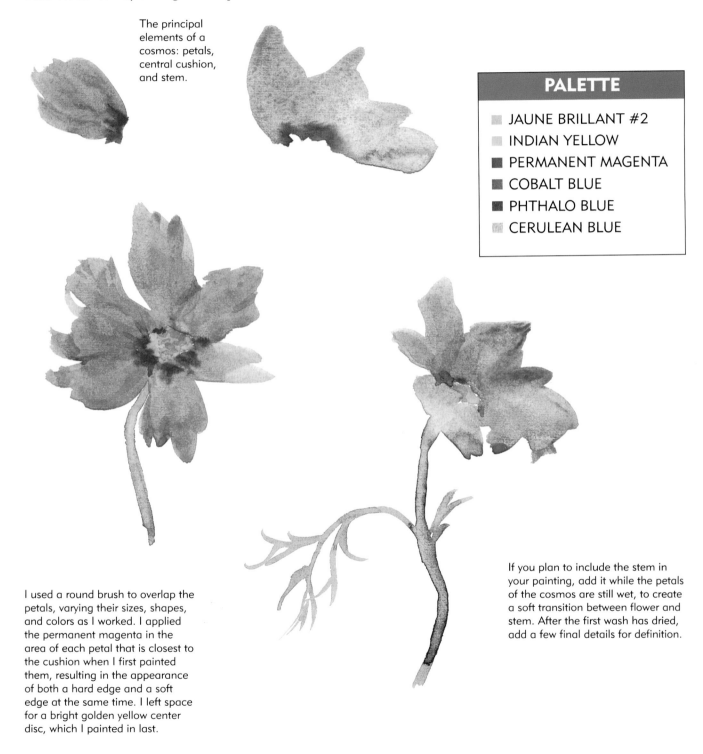

The principal elements of a cosmos: petals, central cushion, and stem.

PALETTE

- JAUNE BRILLANT #2
- INDIAN YELLOW
- PERMANENT MAGENTA
- COBALT BLUE
- PHTHALO BLUE
- CERULEAN BLUE

I used a round brush to overlap the petals, varying their sizes, shapes, and colors as I worked. I applied the permanent magenta in the area of each petal that is closest to the cushion when I first painted them, resulting in the appearance of both a hard edge and a soft edge at the same time. I left space for a bright golden yellow center disc, which I painted in last.

If you plan to include the stem in your painting, add it while the petals of the cosmos are still wet, to create a soft transition between flower and stem. After the first wash has dried, add a few final details for definition.

ROSES

With its delicacy, lushness, and elegance, the short-lived rose is one of the most beautiful and popular of all flowers. Because of its complex layers of petals and ever-changing shape—varying from a cylinder as a bud and opening to a circle (as viewed from overhead or the front) or a triangle (from the side)—the rose is also one of the most difficult flowers to paint. Don't let the fickle rose intimidate you; just try to remain flexible and focus on the most prominent shapes.

The principal elements of a rose: petals, stem, and leaves.

To paint multipetaled shapes, start at the top of the flower and work down. Using a round brush loaded with thinned transparent color, work first from right to left, then left to right, in the configuration of an S stroke.

As viewed from the front, a rose can be seen as a half circle of petals that emerge from within the bloom, emanating from its center. (See also "Complex White Floral Forms," page 81.)

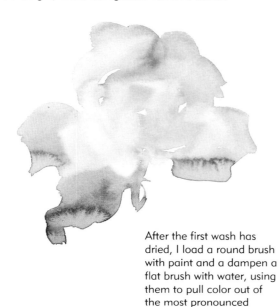

After the first wash has dried, I load a round brush with paint and a dampen a flat brush with water, using them to pull color out of the most pronounced petals. I do this slowly and carefully, squinting at the rose as I work.

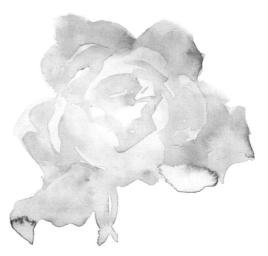

As most roses are more intensely colored at their centers, you should change the color on your brush as you work toward it. Rinse the brush first, then add some darker-valued yellow, letting all the colors run together on the paper. At this point, rather than worrying about painting an exact number of petals, I concern myself with the subtle color changes within the bloom and the silhouette of the outer shape, so that even with little or no definition it strongly implies the impression of a rose. I then immediately begin painting the leaves, in order to achieve what can be an elusive transition. Any crawlbacks that occur can create lovely textures.

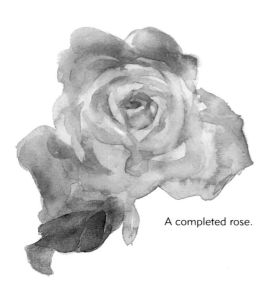

A completed rose.

PALETTE
▦ JAUNE BRILLANT #2
▢ INDIAN YELLOW
■ PERMANENT ROSE
■ PHTHALO BLUE
▦ PERMANENT GREEN LIGHT #1

TULIPS

The vibrant colors of tulips are a wonderful watercolor subject. Although the shape of a tulip's flower may at first glance appear simple, if you look more carefully you'll see many subtle curves and angles. Tulip leaves are also subtly complex; their energetic twists, turns, and angles can inspire even the most experienced artists.

Constantly moving and bending in response to the direction and intensity of the light, they present a special challenge to artists. Sketch in the positions of the tulips in your arrangements as soon as possible so that you then need only to refer to the flowers themselves for specific information about color and value.

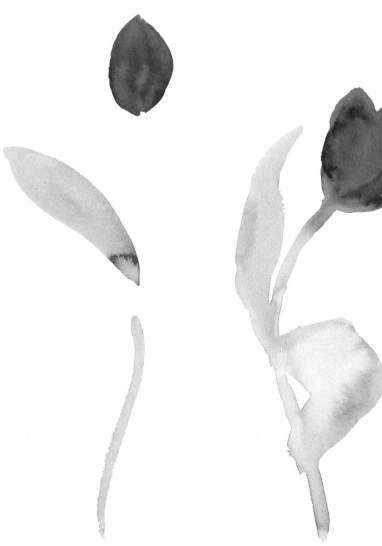

The principal elements of a tulip: petals, stem, and leaves.

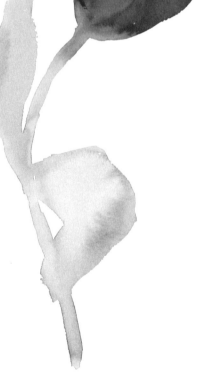

Starting with the bud and working down toward the stem and leaves, I let their colors merge on the paper.

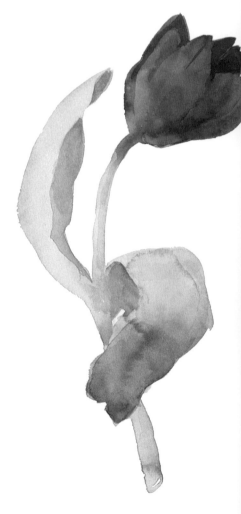

I then selectively add some very simple negative shapes. Not much detail is necessary—just enough to suggest the flower's form.

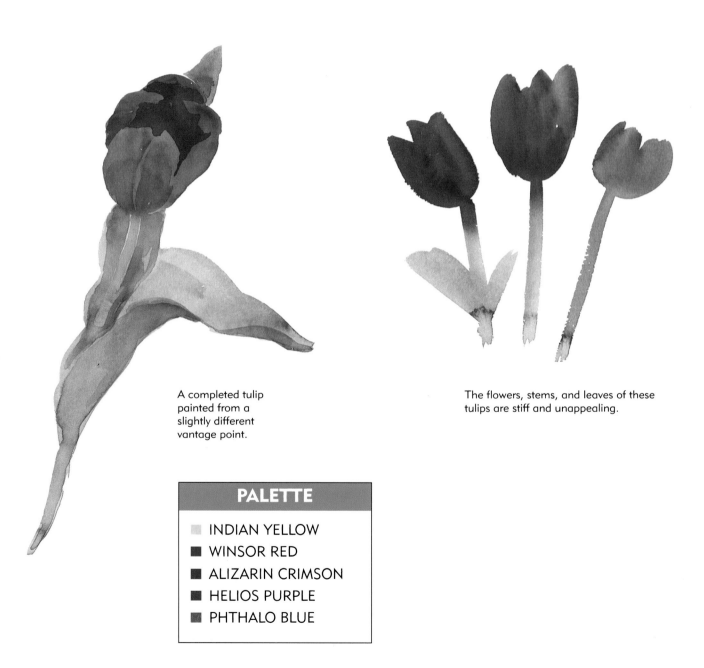

A completed tulip
painted from a
slightly different
vantage point.

The flowers, stems, and leaves of these
tulips are stiff and unappealing.

PALETTE

- INDIAN YELLOW
- WINSOR RED
- ALIZARIN CRIMSON
- HELIOS PURPLE
- PHTHALO BLUE

ZINNIAS

Everyone sees a zinnia differently—as a circle, an oval, or a cone. The zinnia's loose, soft form and large shape make it easily accessible to beginning artists.

Here I'm trying to establish a variety in the color and some rhythm in the outside edges of the flower. I paint either to the right or left, then continue in that direction for the rest of the flower. Outstretched petals can be added after the full circle has been completed. Because the center will be a strong color, I leave it unpainted at this point and just soften the inner edges of the petals with water.

The principal elements of a zinnia: petals, sepal and pedicel, leaf, and central cushion.

The full circle of petals is almost complete. At this stage I would normally add the stem (see opposite) so that the transformation from petal to stem is soft instead of harsh and abrupt.

If you are unfamiliar with the zinnia or haven't yet tried painting a similar flower, I suggest that you tape a sheet of tracing paper on top of the flower before continuing. Squint at the image, then pencil in the important negative shapes. Evaluate the results. Does it read well? Is it too precise? If you're satisfied with the results, remove the tracing and refer to it when adding the shapes. Remember to soften the edges as you proceed.

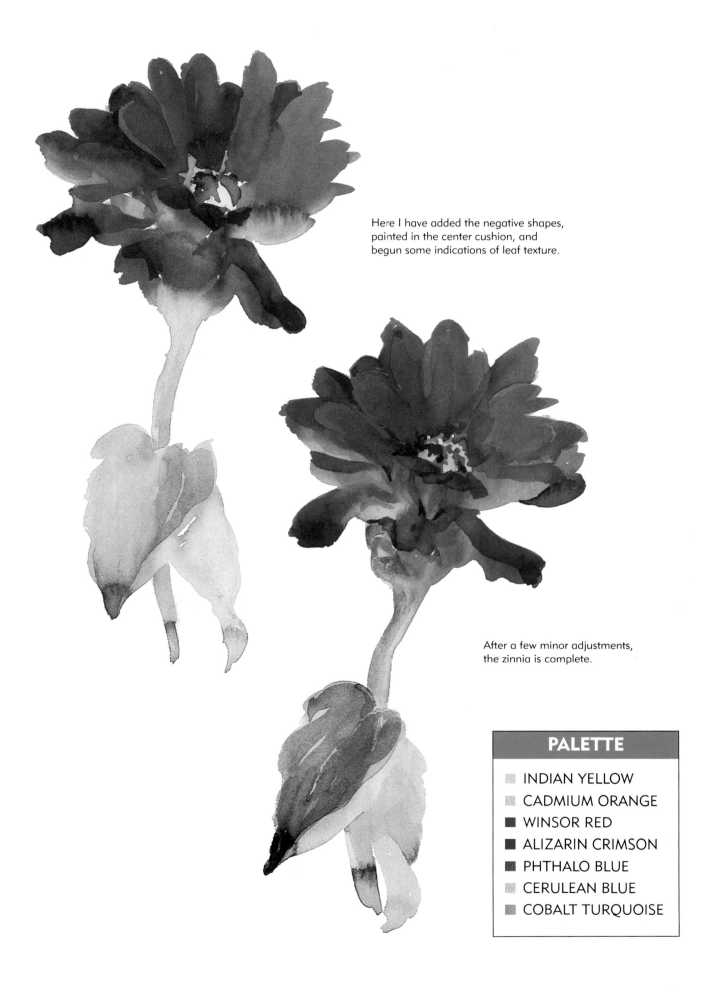

Here I have added the negative shapes, painted in the center cushion, and begun some indications of leaf texture.

After a few minor adjustments, the zinnia is complete.

PALETTE

- INDIAN YELLOW
- CADMIUM ORANGE
- WINSOR RED
- ALIZARIN CRIMSON
- PHTHALO BLUE
- CERULEAN BLUE
- COBALT TURQUOISE

DELPHINIUM

The sinuous multiflowered branches of the delphinium can be somewhat befuddling to paint. If you take your time and try not to paint everything you see, you'll be pleasantly surprised at the results. Squinting to simplify form certainly comes in handy here.

The principal elements of a delphinium: petals, sepal, leaves, and stem.

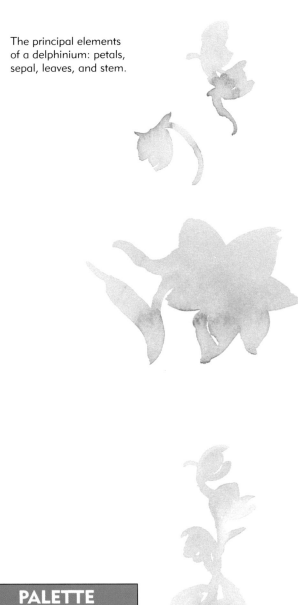

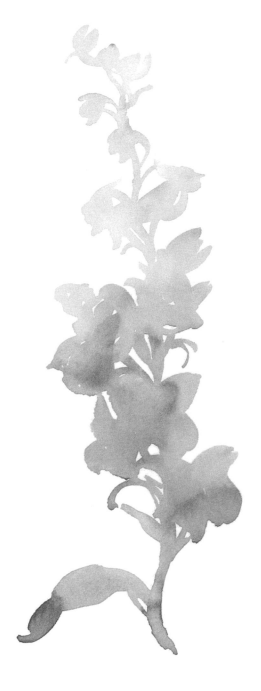

Starting at the top of the stalk, I mix Indian yellow with the various blues directly on the paper to produce a variety of greens. As I work down the stalk I introduce the two violets, moving from the small delicate buds to the larger florets.

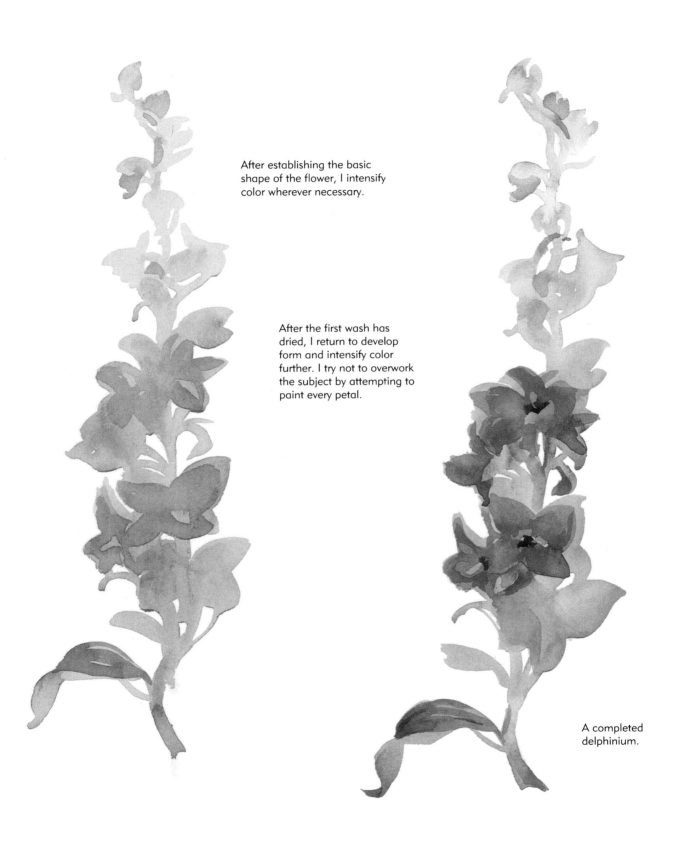

After establishing the basic shape of the flower, I intensify color wherever necessary.

After the first wash has dried, I return to develop form and intensify color further. I try not to overwork the subject by attempting to paint every petal.

A completed delphinium.

IRISES

Color is one of my primary sources of inspiration, and in the spring my garden is a spectacle of bright hues. Irises are one of the star attractions and a painting stimulus that I can always rely on. It's a shame that their flowering season is so short—a heavy rain can be absolutely tragic.

In order to keep from overworking a painting, work on several of the same subject simultaneously; for example, picking up on one as the first wash of another dries, and so on. You can take full advantage of your short-lived models if you make many starts, rather than laboring to complete a single painting at a time.

After purposely placing one iris on top of the other, my challenge for the finished painting will be to delicately balance the visual strength of the flowers with their foliage.

PALETTE

- JAUNE BRILLANT #2
- INDIAN YELLOW
- CADMIUM SCARLET
- RAW SIENNA
- BURNT SIENNA
- COBALT VIOLET
- PHTHALO BLUE

I painted these four iris studies during a recent spring, only a few of many that I did over a two-day period that I felt were worth keeping. Don't be discouraged by how finished they look; remember that I'm extremely intimate with the subject matter, as I have watched irises bloom every spring for years. I've tried to capture the complexity of these beautiful flowers with a minimum of detail. I gave the placement of the flowers within the frame of the paper careful consideration, and positioned them in an area where I can continue later without a lot of difficulty.

Although the results shown here could not have been achieved by referring only to detailed photographs, I plan to refer to the many photographs of iris foliage I've taken as an aid in composing the finished painting, choosing from among the aspects shown.

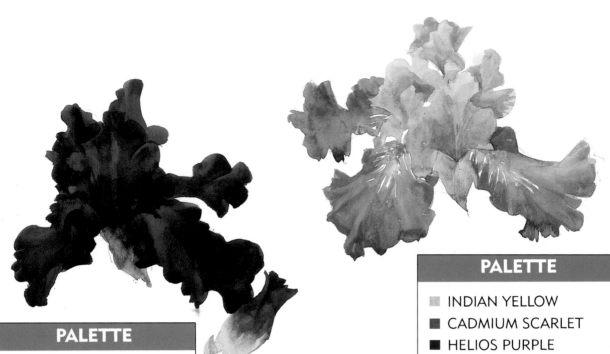

I plan to use the visual information I gathered in these studies of Japanese irises in two paintings. Because of their delicacy and relatively small size, I painted them with more foliage, so I already have a head start on my compositions.

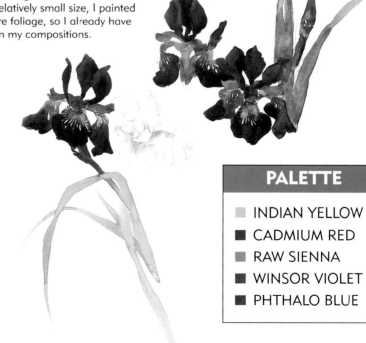

LILIES

The shapes of the elegant lily can be a lot of fun to paint. Because it is edged in white, the stargazer lily is treated the same as a white flower (see "Simple White Floral Forms," page 80).

I begin the lily by drawing its basic shape. When I look at one from overhead it resembles a star, and from the side it looks like a triangle. In the process, I also try to exaggerate its scalloped edges.

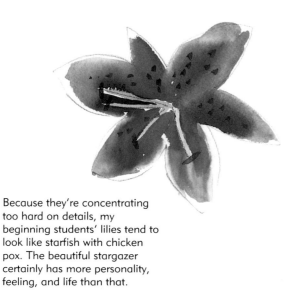

Because they're concentrating too hard on details, my beginning students' lilies tend to look like starfish with chicken pox. The beautiful stargazer certainly has more personality, feeling, and life than that.

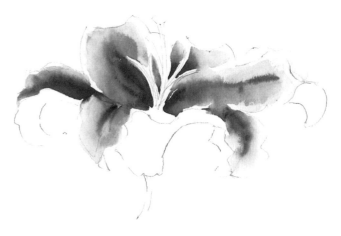

The principal elements of a lily: petals, stamen and pistils, stem, and leaves.

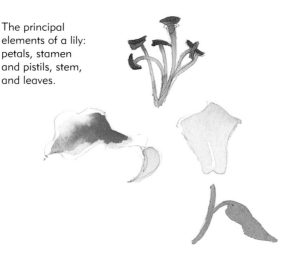

After I finish drawing the petals, I load a round brush with alizarin crimson and, working from the center out to the edges, begin painting them. Next I use a dampened flat brush to slowly pull the paint out toward the edges, making sure to leave soft edges and the white of the paper showing. I work in a circular pattern, waiting to paint the stamens later. (As a precaution, you might try covering the stamens with White Mask first.) When the paint is partly dry, I use a flat brush to selectively add the freckles in groupings of three, four, and five.

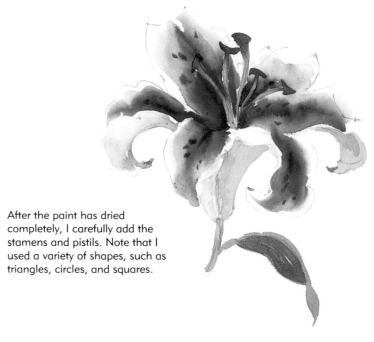

After the paint has dried completely, I carefully add the stamens and pistils. Note that I used a variety of shapes, such as triangles, circles, and squares.

PALETTE

- JAUNE BRILLANT #2
- CADMIUM ORANGE
- ALIZARIN CRIMSON
- BURNT SIENNA
- PHTHALO BLUE
- PERMANENT GREEN LIGHT #1

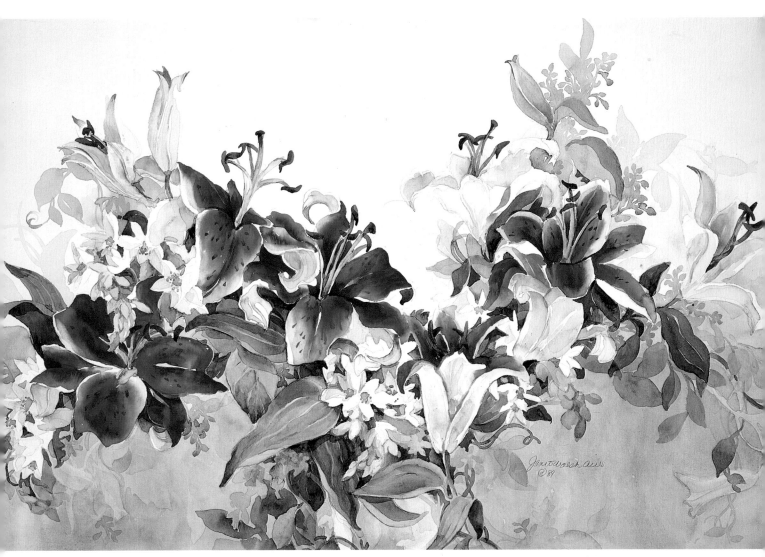

LILIES ON THE LINE
Watercolor on 140-lb Arches cold-pressed. 22 x 30 inches (55.9 x 76.2 cm). Collection of Ms. Chikako Kawada, Ibaragi, Japan.

This painting was based on several flowers, and evolved slowly over a period of days, as the lilies gradually bloomed from bud to full flower. I first sketched in rough drafts of a few bud shapes, and as time passed and the flowers opened I studied them from every angle, looking for shapes that would work well in the painting that was taking shape.

If your access to flowers is limited, this approach is a wonderful way to explore shape and composition. The simple acts of gazing at a flower and turning it in your hand become a visual lesson.

CHAPTER SIX

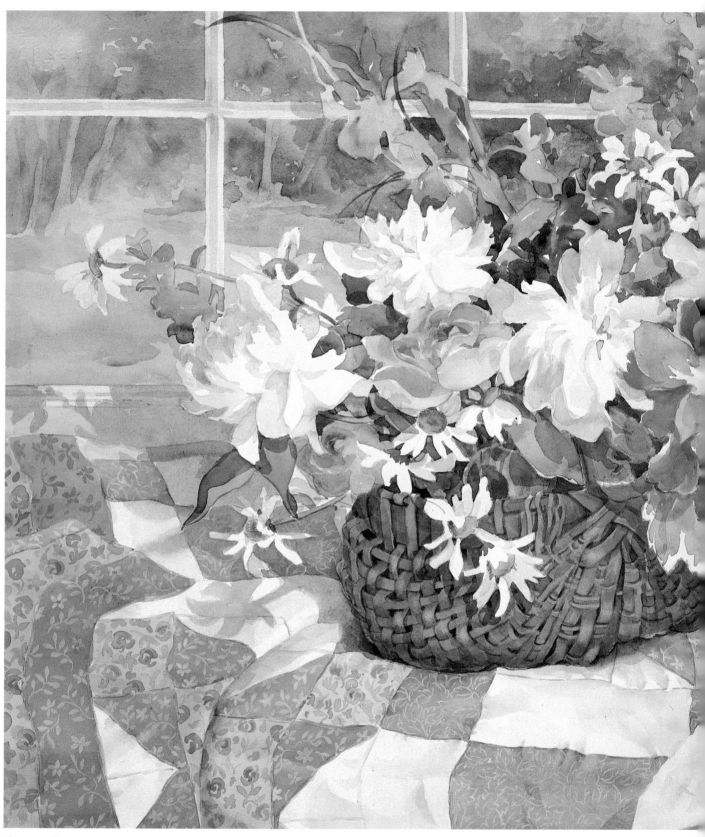

GARDEN RHAPSODY
Watercolor on 140-lb. Arches cold-pressed. 22 x 30 inches (55.9 x 76.2 cm).
Collection of Molly and Philip Michael, Tavenier, Florida.

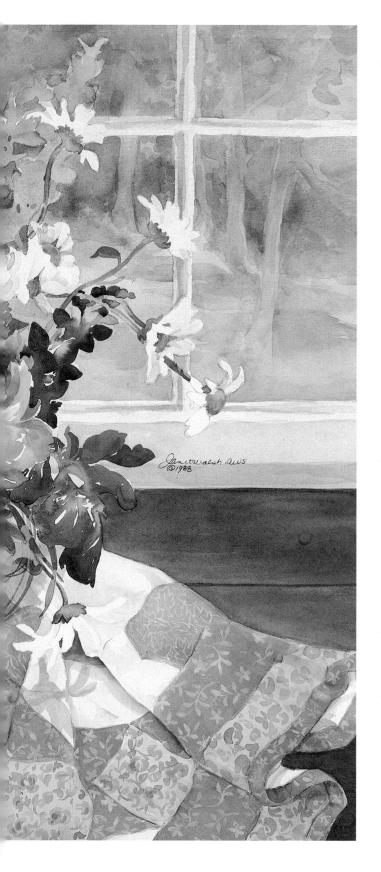

Saving and Painting Whites

In watercolor painting, white forms are handled in one of two ways. Rather than using white paint, the artist expresses the highest value, or white, as the unpainted white of the paper. For this technique, white forms are "saved," or kept free from paint, either by carefully painting around their sketched shapes, or by covering them with a masking fluid such as White Mask and removing it after the surrounding washes or glazes have been painted in. After establishing the overall composition, the artist must then decide whether, as well as how, to convey the subtle touches of color that exist within the shaded areas of a white object.

The challenge of expressing white in watercolor can frustrate the beginner as well as the experienced artist. One common problem is that artists unintentionally skimp on the whites they reserve, making them too small to develop adequately as the painting progresses. Sometimes, in response to the starkness of the white of the paper, artists overpaint their whites, obliterating them with dull or grayed colors. In this chapter, I show how to overcome these obstacles by exaggerating a subject's size, angles, and curves. As you can see, I use this approach when I draw in basic forms, and as I paint I embellish them further.

SIMPLE WHITE FLORAL FORMS

There are three basic techniques that can be used either alone or together to define a white shape in a watercolor painting: (1) Sketching in the object's silhouette in pencil, (2) painting negative shapes in either strong values or delicate tints behind or alongside the white object's positive forms, and (3) painting in a pale tone on the white shape itself.

Painting a white daisy is an excellent introductory exercise in defining whites; its simplicity and sturdy nature make it an ideal subject. A daisy is composed of many flat petals emanating from a circular central cushion. Shown here are some of the problems encountered by many students, along with a few suggested solutions.

The somewhat limited approach of painting everything you see—which usually means that you've included more than is absolutely necessary to represent your subject—is certainly not restricted to depicting white forms. Even if your subject is perfectly symmetrical and all its petals are regularly spaced, painting it as you see it will result in a lackluster treatment.

Using a dull-colored wash to express negative space, especially around a white object, will form a rough-edged halo that becomes difficult to soften or remove later.

If you look closely at the centers of several daisies, you'll notice that not every one is a perfect circle. Take advantage of the variety you'll find within your subjects to create interest in your paintings.

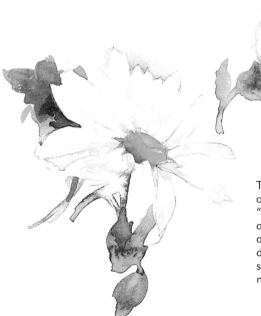

The technique of varying the number of forms within a grouping (see "Simplifying Foliage Forms: Problems and Solutions," page 35) can also be applied to flowers. When painting a daisy, for example, group the petals in sets of 2, 3, 5, and so forth, for a more appealing result.

PALETTE

- CADMIUM LEMON
- INDIAN YELLOW
- CADMIUM ORANGE
- CADMIUM SCARLET
- PERMANENT ROSE
- COBALT VIOLET
- PHTHALO BLUE
- CERULEAN BLUE

The whites in your paintings can create sparkle and life. The colors shown at right are very light tints of colors, both warm and cool, from our standard palette. I use plenty of water to thin them to the right consistency for transparent glazes and pale washes.

| CADMIUM LEMON | INDIAN YELLOW | CADMIUM ORANGE | CADMIUM SCARLET | PERMANENT ROSE | COBALT VIOLET | CERULEAN BLUE | WINSOR VIOLET |

COMPLEX WHITE FLORAL FORMS

After you've mastered a few simpler flowers, try your hand at a white rose. This magnificent flower embodies two difficult painting problems: an intricate structure and the challenge inherent in rendering white objects in watercolor.

Before you start your painting, try sketching a few simplistic versions of a rose's underlying structure. Then make a more complex pencil sketch indicating the pattern of the overlapping petals. Use this sketch only as a guide—resist the urge to paint every petal— and concentrate instead on the rose's strongest shapes. In this kind of flower, I look for a maze of interlocking shapes, then record their outlines with my brush.

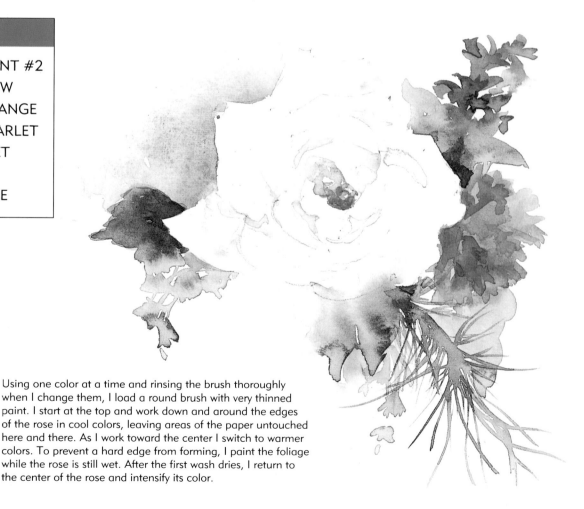

PALETTE

- ■ JAUNE BRILLANT #2
- ■ INDIAN YELLOW
- ■ CADMIUM ORANGE
- ■ CADMIUM SCARLET
- ■ COBALT VIOLET
- ■ COBALT BLUE
- ■ PHTHALO BLUE

Using one color at a time and rinsing the brush thoroughly when I change them, I load a round brush with very thinned paint. I start at the top and work down and around the edges of the rose in cool colors, leaving areas of the paper untouched here and there. As I work toward the center I switch to warmer colors. To prevent a hard edge from forming, I paint the foliage while the rose is still wet. After the first wash dries, I return to the center of the rose and intensify its color.

WHITE VEGETABLE FORMS

I originally painted this watercolor to show my students that texture can be established through the use of several techniques: by varying the temperature of a color; by using a variety of different greens; by painting wet-in-wet in foliage; and by taking advantage of crawlbacks. This painting also demonstrates how carefully preserved whites and a gradual reduction in value—even of the most delicate glazes—can be used to create form.

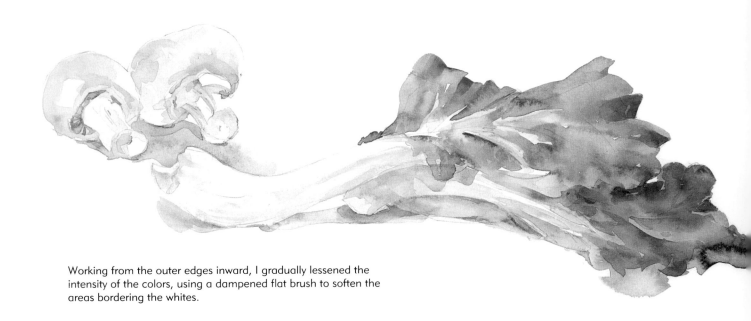

Working from the outer edges inward, I gradually lessened the intensity of the colors, using a dampened flat brush to soften the areas bordering the whites.

PALETTE
CADMIUM LEMON
INDIAN YELLOW
CADMIUM ORANGE
PERMANENT ROSE
WINSOR VIOLET
PHTHALO BLUE
COBALT TURQUOISE

Using White Shapes to Produce Movement and Linkage

In painting this piece, the challenge was to work with a range of whites, and white on white, while retaining the delicacy of the floral forms, which I wove throughout the lilacs and other flowers I included in the bouquet. This created continuity between the bouquet, the fabric beneath it, and the subtly rendered foreground and background. While taking advantage of my entire palette of colors, I used only their palest values.

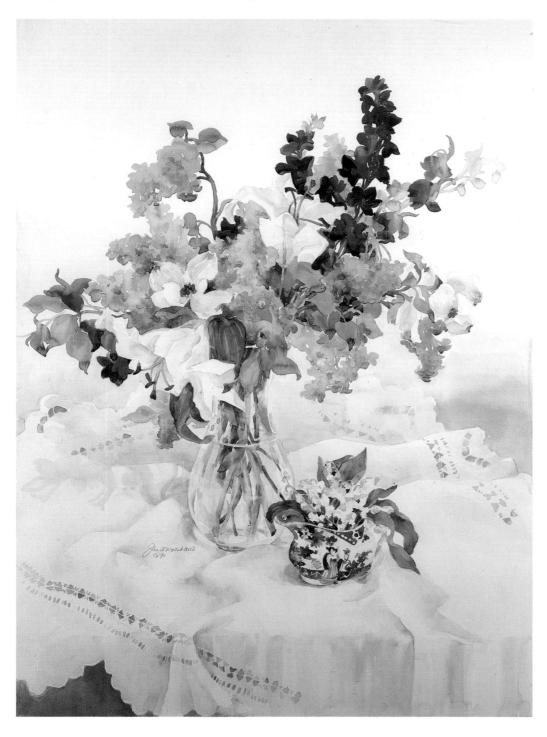

LILACS AND LILIES
Watercolor on 140-lb Fabriano cold-pressed. 30 x 22 inches (76.2 x 55.9 cm). Collection of Mrs. Mizuko Ohashi, Tokyo, Japan.

This subject gave me an opportunity to explore the soft shifts of color that can be found within white while using them to differentiate form. The nearly transparent colors of the lilacs serve as a perfect bridge between the whites of the lily and the dogwood blossoms and the strong values of the delphiniums.

VARIATIONS IN VALUE

I simplified this garden scene by reducing it to bands of color: a dark purple sky; a trail of wine-colored irises and their low-value foliage; then exaggerated white shapes dancing through lighter, softer foliage. Note the rhythmic effect of the two- and three-flower clusters of simply rendered white blossoms, whose pattern accentuates the outlines of the iris leaves. Had I painted the flowers individually, this rhythm would certainly have been lost.

The colors of the leaves are various mixtures of phthalo blue and Indian yellow, with other colors added as needed. As with *Lilacs and Lilies* (previous page), I used the entire palette in this work, limiting the range of values within certain areas.

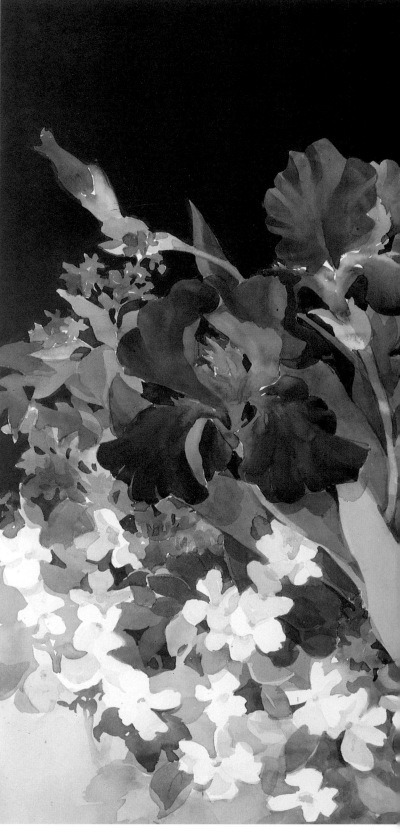

LACE CURTAIN IRIS
Watercolor on 140-lb. Arches cold-pressed. 22 x 30 inches (55.9 x 76.2 cm). Collection of Museo de la Acuarela, Mexico City, Mexico.

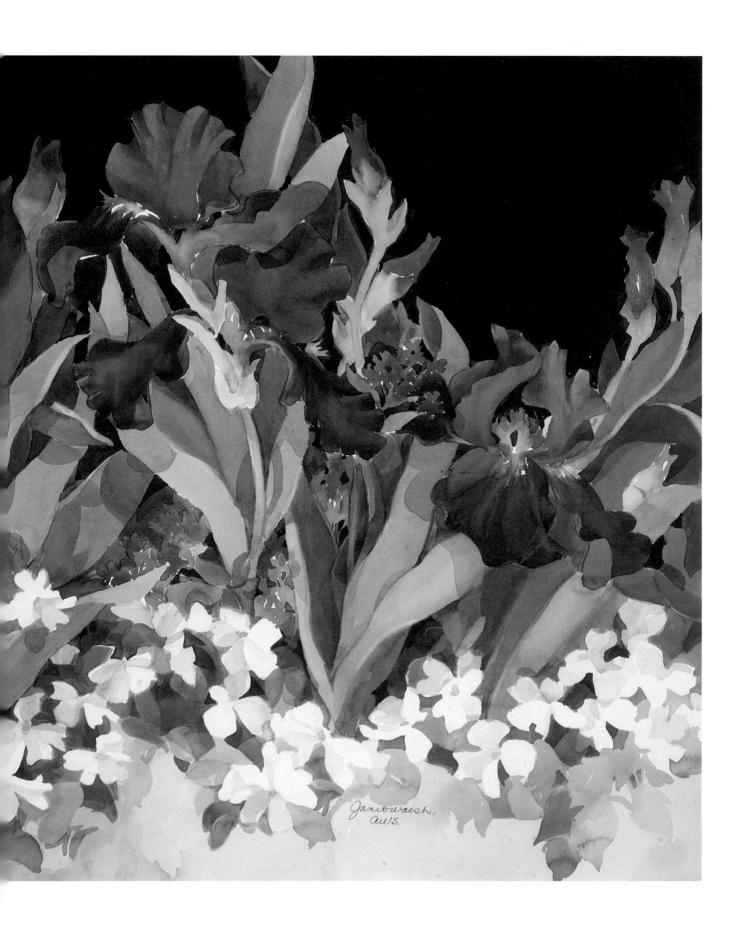

CHAPTER SEVEN

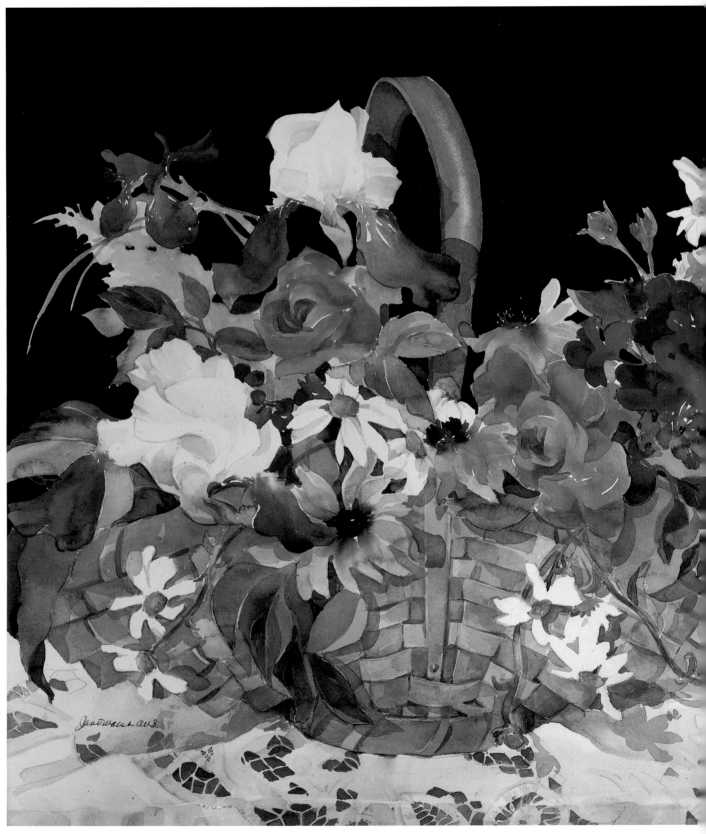

Basket & Lace
Watercolor on 140-lb. Arches cold-pressed. 22 x 30 inches (55.9 x 76.2 cm).
Collection of Anna Schalk, Long Island, New York.

Integrating the Supporting Elements

Setting up a still life can be a great learning experience. As you build your composition, you'll discover that there are many ways to compose an effective image. Keeping an open mind about the details as you work, start with something simple—a bouquet of flowers with a strong profile, a simple opaque container, a remnant of fabric in a solid color— then gradually build toward more complex arrangements. Include whatever you like or have on hand, arrange them as you please, choose the direction and intensity of the lighting, and choose a background that complements all.

Regardless of the elements you choose to include in a specific painting, remember that they must reflect your goals in painting it. Your primary interest—whether the flowers, their container, or the colors in the composition—should always dominate.

CONTAINERS

When I set up my floral compositions, I give the container for the bouquet considerable thought before making a selection. Having an array of pottery, glassware, and baskets to choose from doesn't necessarily make my decision easier. While it's great to have many options from which to choose, the requirements of a painting—the balance of its colors, proportions, and composition—should always take priority over your preferences for a particular container's color, texture, or size.

When choosing a container, think carefully about your painting's intended focus: Is it the bouquet, the container, or perhaps some other object or element? As always, color is an important consideration. I prefer to repeat the colors of the bouquet in the container, whether an opaque clay pot, a transparent glass vase, or a woven basket. Choosing the right size of container—and depicting it in a balanced way within a painting—can be especially troublesome for beginning students. They tend to choose containers that are too large for their compositions, then proceed to exaggerate their significance by painting them so that they completely dominate the work. I always tell my students to look at Van Gogh's *Irises* and *Sunflowers* and at Monet's *Chrysanthemums*. The containers depicted in these paintings are very small—the emphasis is unquestionably on the flowers—and my more observant students notice that the containers are in fact too small to fit all the stems of their bouquets. I begin to think about how to paint a container only when the bouquet is about three-fourths completed, so that I have a clear idea about the direction I want the painting to take.

BASIC CONTAINER SHAPES

The shapes of most simple containers are symmetrical. This can also be said of many complex containers, even those whose curves and angles make them at first seem asymmetrical. The sequence below illustrates the steps involved in rendering simple container forms, then applies the technique to a more complex form.

After you've decided on an appropriate width and height for the container in your painting, mark the paper lightly with four pencil marks indicating its perimeter at top, bottom, and sides, then sketch a faint line marking its central axis. Next, draw the ellipses at the top and bottom of the container. Your position will affect the appearance of the ellipses in the sketch. For example, if you're looking down at the container, the ellipses will look wider or rounder than if the container is level with your line of vision, which would make them look thin and flat. The ellipses must be symmetrical and their ends rounded rather than pointed. Once I'm satisfied with my sketch, I erase the farther segment of each ellipse.

For a more complex container, sketch a box of the same height and width, then draw a line down its center. Carefully draw one half of the container within one side of the box.

When you're satisfied with your rendering, copy it on a piece of tracing paper. Remember to mark the center of the container on the tracing before you lift it from the paper.

Some common problems beginners have when drawing a container: *(left)* The top of the container is elliptical, but the bottom isn't; *(center)* the bottom is elliptical, but the top isn't; and *(right)* neither the top nor the bottom is elliptical.

Turn the tracing over and, using a light box (or a sunny window), sketch the contour of the container in the other side of the box.

TRANSPARENT GLASS VASES

A transparent container can be painted using several techniques. One approach is to paint it from a black-and-white photograph of the setup in which the value patterns of the glass are clearly visible. My technique, which is illustrated below, calls for a freer interpretation. The palette for painting transparent glass is the same as that for painting white objects (see page 80).

In this demonstration I will add a glass vase whose shape echoes that of a petite bouquet of sweet peas that I had painted earlier. If this is your first attempt at painting glass, use a white backdrop to simplify the value patterns. Before you start, I also recommend that you cover any flowers that would most likely fall over the rim with White Mask.

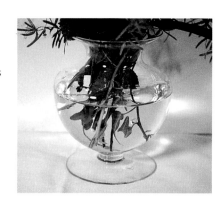

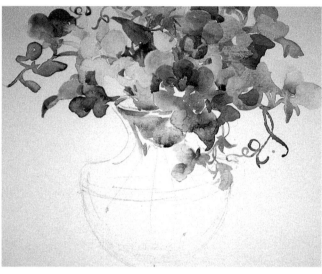

I lightly sketch in the shape of the container, indicating where the stems will fall, and where the water line should be.

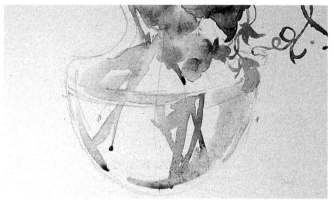

Using very thinned paint, I lay in the stems, their reflections in the glass, and the body of the vase itself, while considering the visual effect of the water in the vase on all the forms. Rather than worrying about whether each stem corresponds to a specific flower in the bouquet, I aim for a visual suggestion of stems within the vase. Then when I paint them in I make them consistent with the body of the glass.

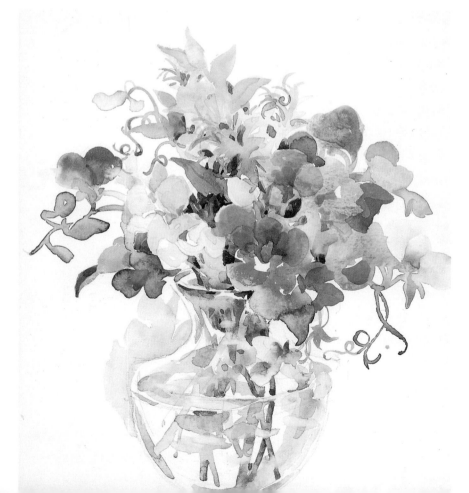

When painting stems in a transparent container, crawlbacks enhance the effects of the water.

The larger value shapes in the container, whose colors I like to blur and let run into each other, repeat some of the colors of the bouquet. (It's a good idea to squint while you paint this area—the blurrier the results, the better.) After the paint dries, you can add dark touches or lift color as needed.

BASKETS

When I decide to include a basket in one of my paintings, I've usually spent a lot of time getting to know its structure first.

When painting a very detailed container such as a basket, first sketch an informal skeleton of it on a piece of tracing paper that you've taped over your painting.

That way, you won't have to spend time and effort drawing it directly on the paper—where the risk of damaging the paper by making revisions is very high—only to find that after it's finished you want to move it half an inch to the right or left. While painting the basket I use the tracing paper sketch as a general guide rather than as a model whose every detail must be duplicated.

One of the tracings I made for *Peg's Basket*. The blank areas at the top are for the foliage and flowers that fall there. I then transferred this drawing to the painting.

I used both a round and a flat brush to paint in some negative areas in order to establish some of the basket's texture. Note the variety of hard and soft edges throughout.

Starting at the top of the basket and working from left to right, I used a series of broad S strokes to apply the color. As I move the round brush across the image I use the flat as a mahl stick. At right are the results of a single wash; you may choose to add another. I didn't like the way the gaps in the top of the basket looked so I filled them in with foliage.

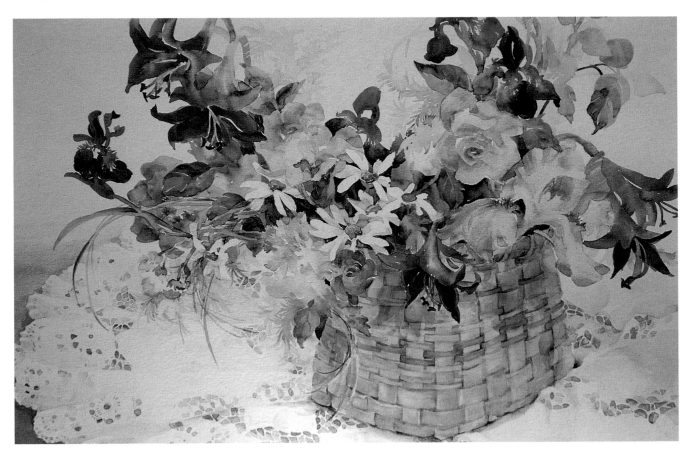

Peg's Basket
Watercolor on 140-lb. Fabriano cold-pressed. 22 x 30 inches (55.9 x 76.2 cm).
Collection of Margaret Wolfe, New York City.

FABRICS

Before I started painting seriously, I made most of my clothing as an outlet for my creativity. I still love to browse in fabric stores, looking for patterns and textures that I might someday use in a painting. When selecting fabric for a particular painting, I think about what I would like to accomplish: Do I want to repeat a rhythm that's discernible in the bouquet? Do I want the fabric to blend softly into the background? Or does the painting need some energy or "punch"? I often try three or four different layouts before I'm satisfied.

Sometimes I change the fabric after the bouquet has been painted, simply because I've changed my mind or because I realize that something else would work better. Remember that the fabric you choose must work for you.

If you're not sure about how to proceed, research can be a great help. Go to the library and browse through some books about fabrics or on art history, to see how artists from earlier eras handled this element in their work.

DEMONSTRATION: PAINTING WHITE FABRIC IN FOLDS

Painting white fabric is an excellent exercise for a beginner. It's easier concentrate on folds, reflections, and subtleties without having to consider color or pattern. For this demonstration I selected a stiff white cotton duck, which holds its folds for a long time.

When I arrange fabric I try to create letterforms like Vs, Ws, Ks, and Os in its folds; the movement created by these soft patterns helps guide the viewer's eye through the painting. I included a small basket so that I would have something to paint in relation to the fabric.

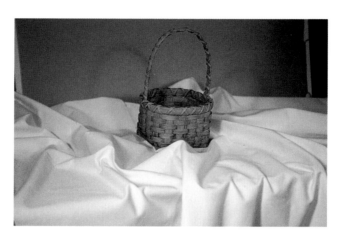

PALETTE

- CADMIUM LEMON
- CADMIUM ORANGE
- CADMIUM SCARLET
- COBALT VIOLET
- COBALT BLUE

I first lay in the basket so that I can accurately depict the light that reflects from it onto the fabric.

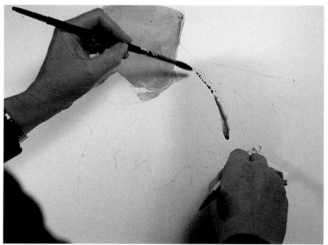

As I usually do, I use a round brush to apply color and a flat brush dampened with clean water to soften edges, which will create volume in the folds and give the entire composition depth.

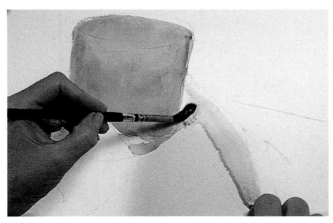

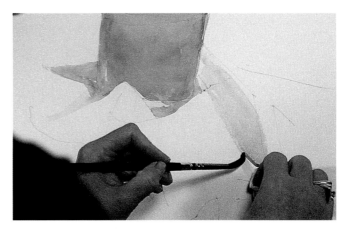

I bring the color of the basket into the fabric to establish continuity between the two elements.

The transparent consistency of the paint and the very light values of the colors allow me to blend them together easily as I add them. Here I blot the bead of paint with a facial tissue.

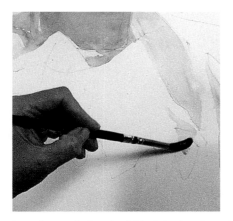

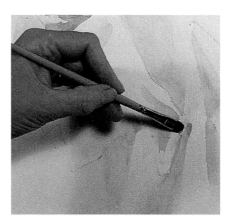

I continue painting the folds, bringing the colors down into the foreground, intensifying them slightly to create depth.

Once the paint has dried a certain amount of adjusting will be necessary to soften and blend it. A scrubber comes in handy for this.

The completed demonstration.

ADDING FABRIC TO A PAINTING

I arranged this bouquet of hydrangeas as part of a workshop demonstration. The sheer size of the bouquet required considerable thought as to the most effective placement within the frame of the paper. Fortunately the translucent pale aqua vase was an excellent companion for the bouquet, as it repeated its shape and complemented its color well. This subject required very little preliminary drawing, and I was able to exaggerate some of the nuances of color as I worked. I added the fabric later by creating a tracing paper sketch to serve as a guide to incorporating the soft folds. I'm very pleased with the results: The supple, flowing folds of white fabric beautifully complement the graceful cascades of hydrangea blossoms.

HYDRANGEAS
Watercolor on 140-lb. Fabriano cold-pressed.
22 x 30 inches (55.9 x 76.2 cm). Collection
of the artist.

As with all the glass containers I paint, this rendering is merely a suggestion of the actual vase. Obviously there were many more stems in the jar than I chose to portray; it was clear that the rhythm of the stems should be painted as directly as possible, to balance the rich texture of the bouquet and the opulent color of the vase.

LACE

Because of the intricacy of its white shapes, lace is another common stumbling block for watercolorists, who either lack the patience to explore its complexity or are so preoccupied with painting the flowers that they don't want to spend time working on the lace. If you fall into the second category, create a setup consisting solely of lace so you can practice painting it without any distractions. Develop your skill by concentrating on the tiny dark holes that are typical of many lace patterns. Fine lace-making is an ancient art form, and when I include lace in my paintings I try to treat it as such. I prefer to create the suggestion of lace, rather than to paint it precisely. Note that the palette for painting lace is the same as that for painting white fabric (see page 92).

The tablecloth I used for this demonstration has limited areas of lace patterning; note that your own lace fabrics may consist entirely of openwork. Although the actual color of the cloth is beige, I chose to paint it as white. So that I could see the pattern of the lace more clearly, I placed it over a blue cloth.

To avoid a stiff rendering, I very lightly sketched only the major pattern of the lace in pencil. I then applied some very soft washes of color throughout to establish the texture of the fabric.

After the first wash had dried I began painting negatively, in and around the openings—the essence of painting lace. I varied the size, shape, and color of the holes, then added some shadow patterning here and there.

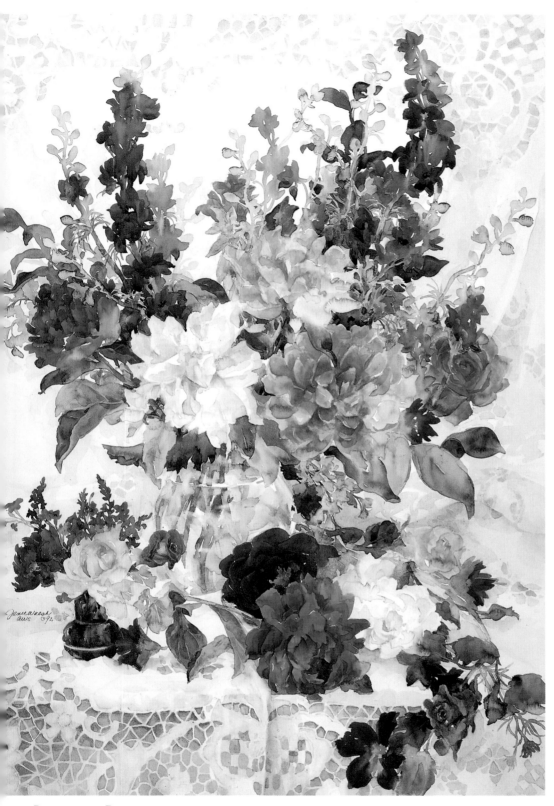

Back at the studio, the process of setting up the fabric was somewhat time consuming. Since the flowers were long gone, I filled the glass vase with some foliage whose stems would serve as a reference. I finally decided that panels of lace across the bottom and top of the pictorial space would complement the rhythms of the bouquet rather than detract from or overpower them. I then added the loose flowers in the foreground, arranging them so that they seemed to almost spill over the edge of the table.

Because I limited the value range within the flowers, the diversity of their color and texture is not jarring.

I made some tracings of the openwork to determine how and where it would work best. After trying a few configurations, I decided to add the small section of lace in the lower left-hand corner of the painting. I lightly sketched the positions of the folds, as well as the larger shapes of the openwork, directly on the paper. I then proceeded to paint the lace, emphasizing some areas and softening others, laying in the smaller openings quickly and intuitively.

PEONIES AND DELPHINIUMS
Watercolor on 140-lb. Fabriano cold-pressed. 30 x 22 inches (76.2 x 55.9 cm).
Collection of Donna Brown, Charleston, South Carolina.

I worked on this painting over a two-year period, as travel and other commitments during the spring and summer prevented me from painting from live flowers. When I paint a bouquet I simply can't refer to photographs—I need the real thing. Then while touring France I found a beautiful lace tablecloth in an antique store and fell in love with the exquisite pattern of its openwork, which I envisioned using in many future paintings.

CHINA BLUE
Watercolor on 140-lb. Fabriano cold-pressed.
22 x 30 inches (55.9 x 76.2 cm). Collection
of the artist.

This is one of my best lace-and-flowers
compositions. A rhythmic pattern of flowers,
fabric, and the openwork of the lace weaves
in and out of the picture plane.

This painting was also an
exercise in white on white:
flowers against fabric
against background.

As I did in *Peonies and
Delphiniums*, I limited the
value range in the flowers
and leaves, which created
the interlocking shapes.

I designed the folds in the
cloth using zigzags, V
shapes, and a few triangles.

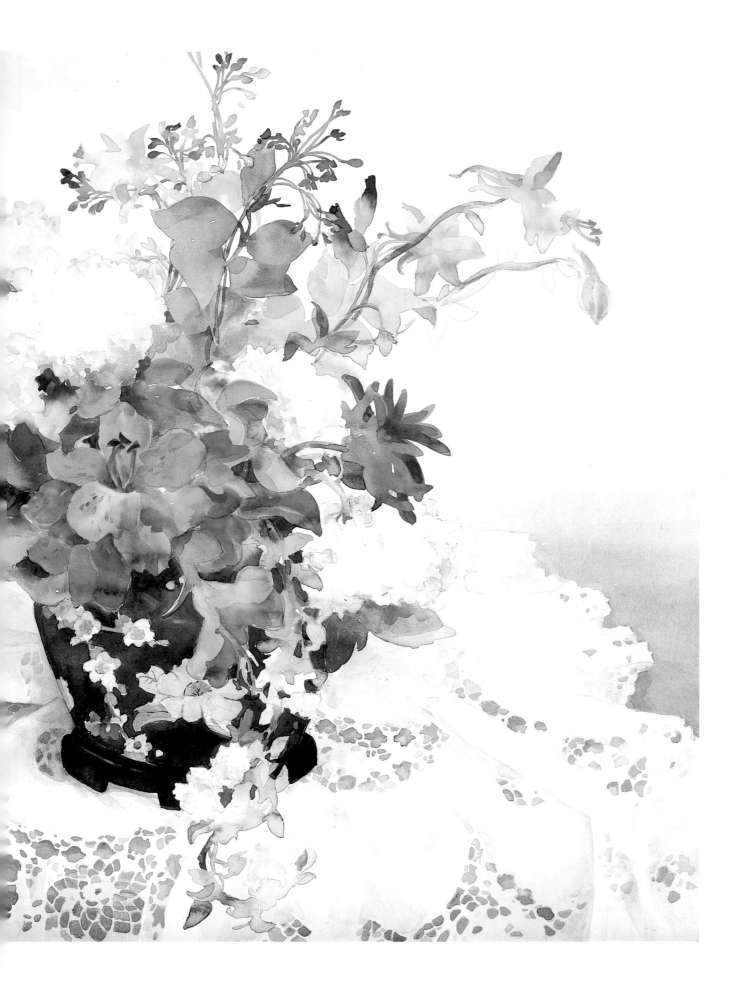

BACKGROUNDS

While I'm in the process of painting a still life I sometimes realize that the actual background is not ideal for that particular composition. For me, the thought that goes into painting a background can take a long time to develop. I base many paintings on one bouquet or arrangement, then set them aside in my studio so that I can browse through them from time to time. Periodically an idea comes to me (sometimes at 3:00 A.M.) about how to finish a painting and what its background should be.

While there is no easy way to surmount a background impasse, you should take the time to expand your awareness of background possibilities. Reference material is very important, as it can send you in a new direction. Keep a camera handy so that you can document future backgrounds wherever you find them.

Museums, books, and magazines contain countless ideas. Begin a clipping file so that if you see something that sparks your interest you have a place to set it aside. You may want to refer to it later, not to copy it, but to interpret it in your own style. Fabric shops and remnants also hold an endless supply of ideas.

There are many ways to incorporate a background into a painting. Some artists begin by painting the background so that the value against which the rest of the colors in the composition will be painted will already be established. Because I often make changes on a painting up to the last moment, and since I paint a series of starts from my short-lived models, my choice in most instances is to tackle the background about three-quarters of the way through, then to adjust the values in the rest of composition as needed.

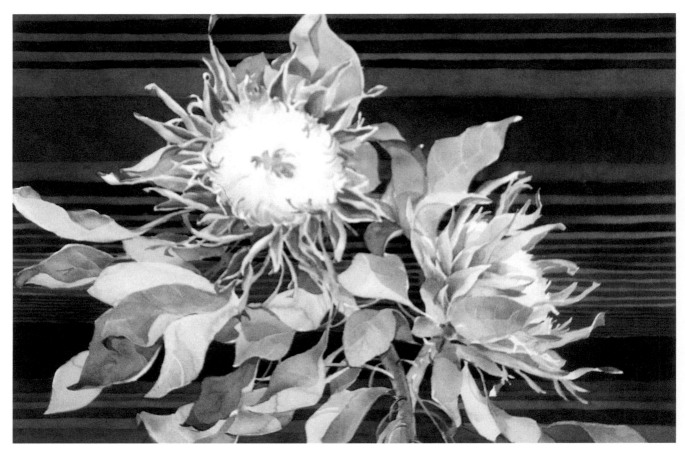

EVENING PROTEA
Watercolor on 140-lb. Arches cold-pressed. 22 x 30 inches (55.9 x 76.2 cm).
Collection of Mr. and Mrs. Kazuyoshi Hara, Tokyo, Japan.

This example of fabric as a background creates a striking setting for the protea. Although the actual fabric was much more decorative and colorful than my interpretation, it was the spark that fired my imagination.

DEMONSTRATION:
PAINTING IN A DARK BACKGROUND

When choosing a color for a dark background, I prefer to mix my darks. My favorite mixture is phthalo blue, Indian yellow, and cadmium scarlet. Other possible mixtures are alizarin crimson and phthalo green, or alizarin crimson and phthalo blue. For the purposes of this particular demonstration I used alizarin crimson, Winsor violet, and phthalo blue. If I use a tube black such as Payne's gray, I mix it with another color.

When painting backgrounds—dark or light—there are a few important rules to follow:

For a smooth wash, the consistency of the paint should be such that a bead of water forms along the brush line. (But not so much that the bead runs down the paper.) With each overlapping stroke, your brush should go through the middle of the bead, thereby carrying it to the end of the background area.

Work on your painting at an angle. So that you are not always painting over it, position your work upside down or sideways. Start at one end—not the middle—and work from the inside to the outside edge.

If you need to apply more than one layer of color, make sure that the previous one is completely dry before adding the next one.

I use deep frozen dessert dishes to mix my background colors. Until you acquire a feel for how much color a particular background will require, it's best to mix more than you think you'll need; otherwise, a hard edge will form if you have to stop to mix more paint.

I started painting the background for this piece at the far edge, positioning it so that it was upside down.

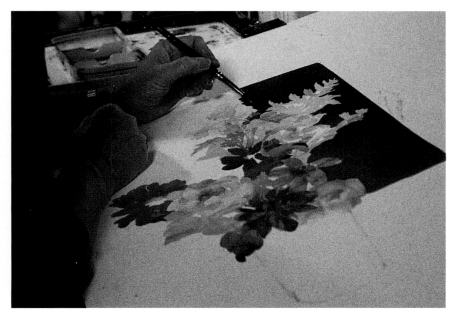

I worked as quickly as I could to fill in the large spaces around the arrangement, then went back to fill in the negative spaces between the smaller forms. To keep the painting from looking like a collection of cutouts, you'll need to make adjustments—such as softening edges or darkening values throughout—after the paint is dry.

PALETTE
■ ALIZARIN CRIMSON
■ WINSOR VIOLET
■ PHTHALO BLUE

DESIGNING THE RIGHT BACKGROUND

I started this painting as a demonstration during a studio tour to raise funds for the local high school art gallery. I had very strong feelings about the results of the demonstration, and decided on a dark background not only to create a mood but to enhance the strength of the bouquet. I put the start aside, as I usually do after demonstrations, and about six months later began to make decisions about how to finish it.

At that time I decided to use a glass container that would repeat the circular shapes of the flowers and carry color into the white tablecloth, which was critical in establishing balance within the painting. I also selected and arranged the stems of the flowers within the glass container as well as the fruit on the tablecloth, both to reprise the round shapes.

It was not until this point that I decided to use a richer value of the permanent magenta that I had used in the flowers and beneath the white tablecloth for the background. I also decided to include an antique mirror in the composition.

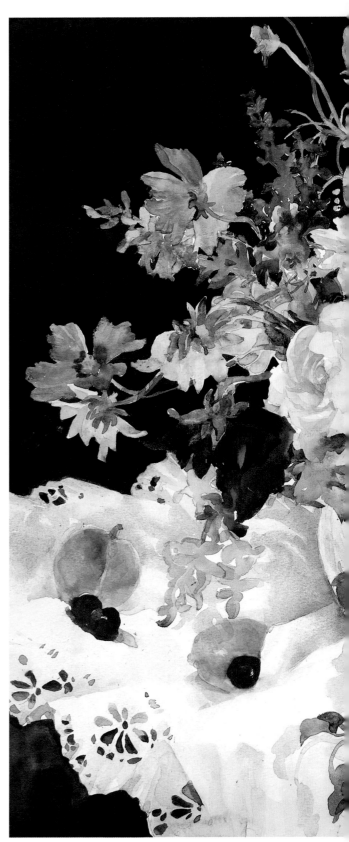

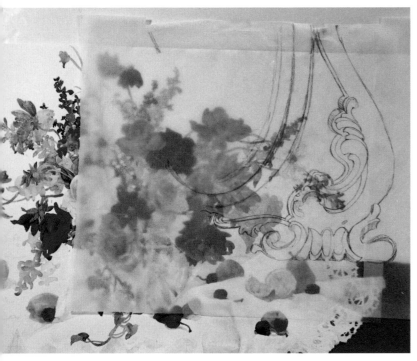

After I sketched the mirror on tracing paper it became clear that its base was too heavily ornamented for the composition, so I eliminated that part of it from the final piece.

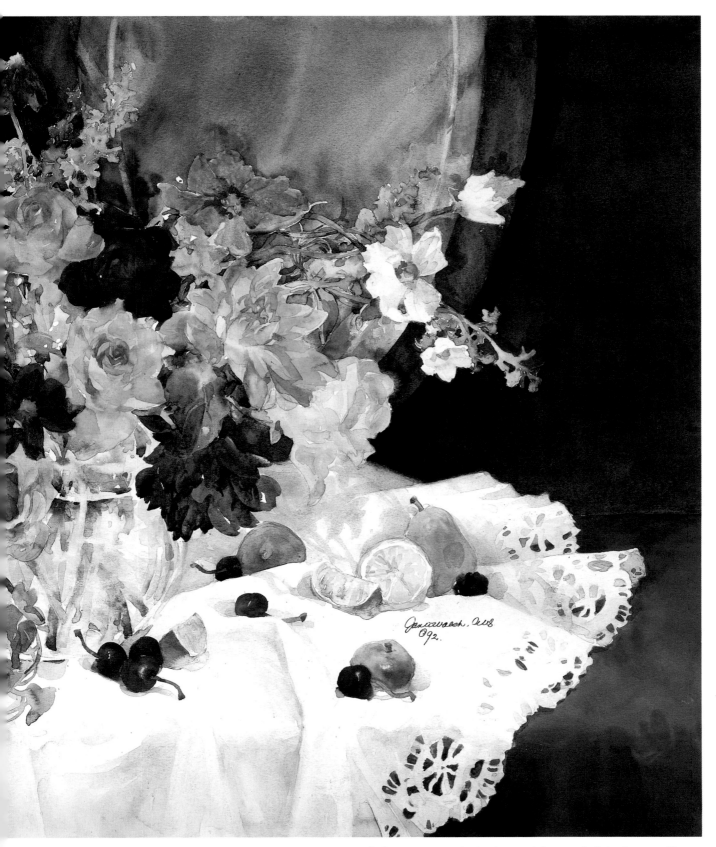

MIRROR
Watercolor on 140-lb. Lanaquarelle cold-pressed.
22 x 30 inches (55. 9 x 76.2 cm). Collection of Mr.
and Mrs. Edward Tancrel, Wilmington, Vermont.

Before painting in the background, I covered all the flowers with liquid frisket so that I could lay in its several washes unhindered. The glass in the mirror, which also required several washes, is composed of grayed versions of the colors that were used in the bouquet.

CHANGING A BACKGROUND YOU'VE ALREADY PAINTED

You don't have to live with a background you don't like or isn't right for a painting just because the paint has dried. Simply protect all the other elements with a layer of White Mask, then use a natural sponge dampened with clear water to remove the background. Although there is a chance that a shadow of it might remain, it can usually be covered with a light-value wash.

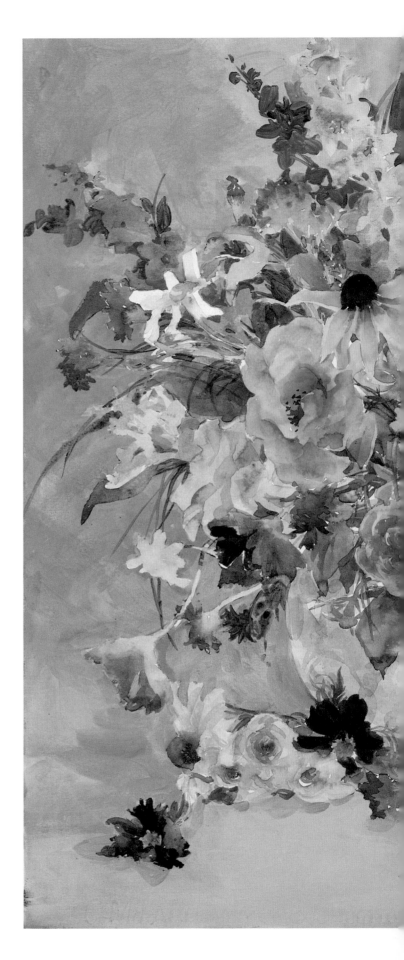

WILDFLOWERS
Watercolor on 140-lb. Fabriano cold-pressed. 22 x 30 inches (55.9 x 76.2 cm). Collection of the artist.

This painting went through several background changes, each of which seemed worse than the one before. I painted it on Fabriano paper, which is soft and difficult to correct, as it doesn't respond well to lifting or scrubbing.

Working with such a delicate bouquet, I wanted to avoid having to paint a dark background to cover my previous mistakes. Instead I chose to use casein, an opaque water-based paint with wonderful covering power. Because I planned to paint with looser strokes and I didn't want to be hindered in any way, I White Masked the flowers completely rather than just their outside edges.

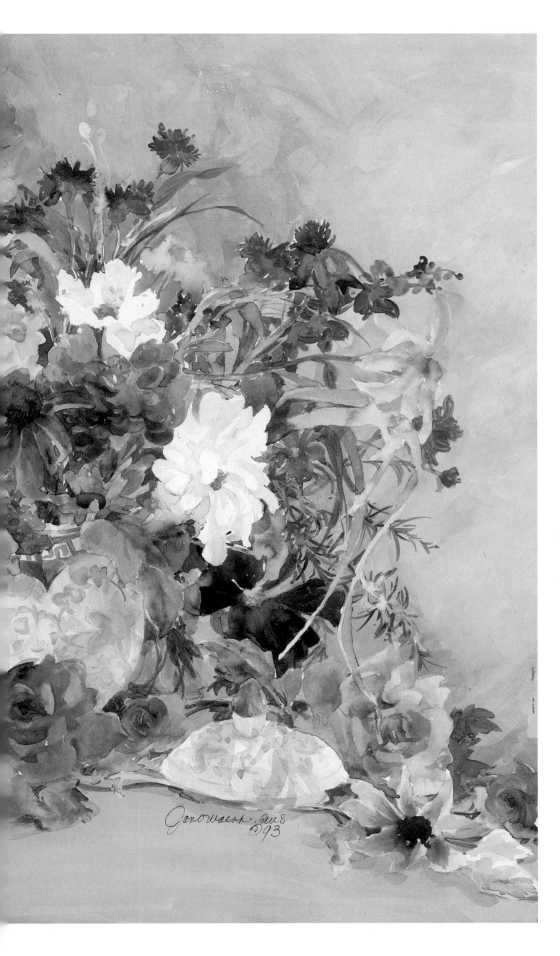

Two layers of casein were required to cover the background satisfactorily. I then returned to the flowers and added a few in casein so that the foreground would be better integrated with the background.

CHAPTER EIGHT

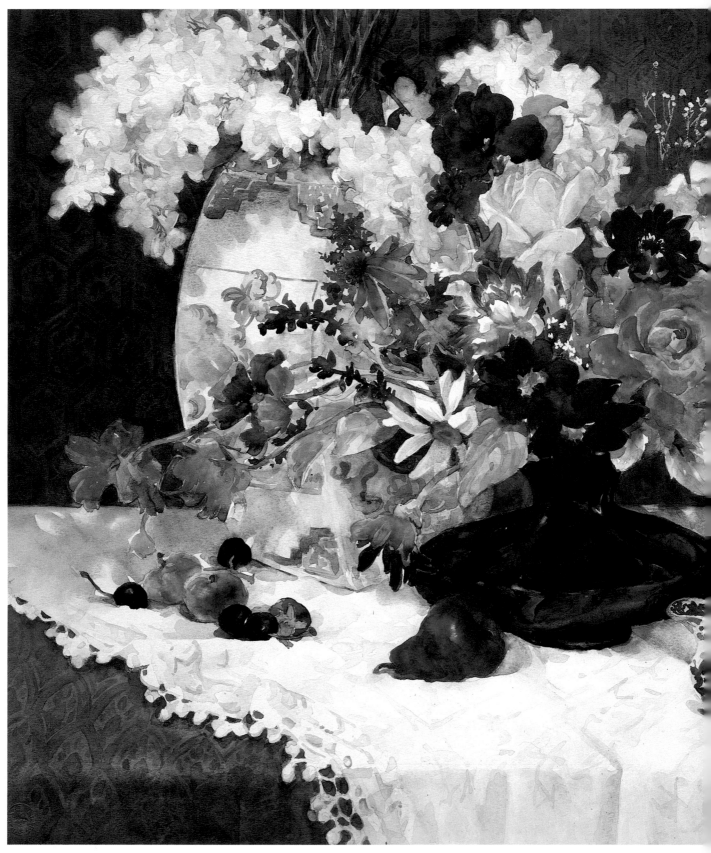

BLUE ON BLUE 2
Watercolor on 300-lb. Lanaquarelle cold-pressed. 22 x 30 inches (55.9 x 76.2 cm) Collection of the artist.

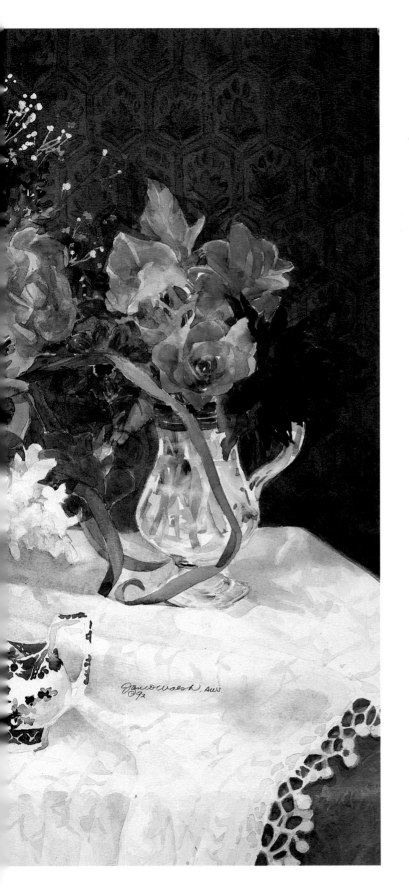

Putting It All Together

After I've decided on and arranged the elements of a composition, I enjoy the process of painting them—singling out, emphasizing, and eliminating details as I work, gradually defining the goals and the focus of the painting. I also try to establish color relationships—between warm and cool, foreground and background, balance and contrast—as I lay in the various shapes, using them to make meaning or to underscore a point. I usually explore a subject more than once, as I'm motivated by the challenge of trying to exhaust its visual possibilities. Each attempt, however, refers to a specific mood and moment in time expressed by texture, detail, color, and pattern.

 Each of the paintings featured in this chapter is described in detail, from inception to completion. It's important for beginning artists to understand the process of painting and completing an image, and apart from doing it themselves—an essential requirement for participating in any creative endeavor— reading about the obstacles that others have overcome can be both informative and inspiring.

DEMONSTRATION: COBALT BLUE VASE

I spend a lot of time arranging a setup, working to achieve a certain vitality through the interplay of rhythm, movement, shape, and texture. However, I usually use my setups only as a suggestion for what my finished painting will look like, and modify and eliminate elements as it evolves.

Floral arrangements in particular can change from day to day, so you have to be flexible. The more familiar you are with your subject matter, the freer you are to improvise. I constantly look back and forth between the painting and the setup, but I don't include everything I observe in the painting.

In this composition I tried to portray the flowers as fresh and as natural as they look in the garden. I included several of my favorite flowers, many of which have forceful shapes and vivid colors. After experimenting with several containers, I settled on a cobalt blue vase, whose strong color provided a counterbalance for the flowers. (My aim here was to keep the viewer's eye moving throughout the painting.) Since there was so much going on in the bouquet, I chose a plain white fabric for a background, which gave me an opportunity to repeat the colors of the bouquet in its folds.

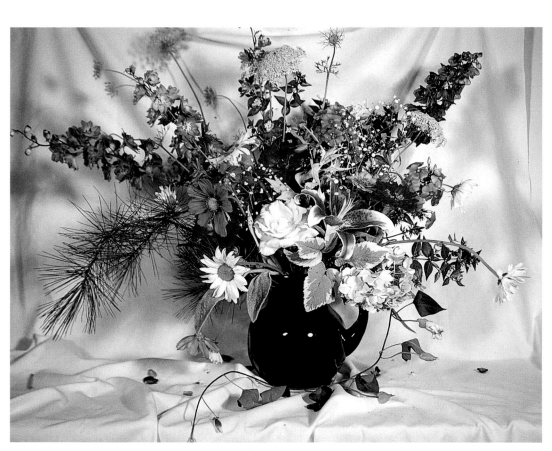

PALETTE

	CADMIUM LEMON	■	BURNT SIENNA
▨	JAUNE BRILLANT #2	■	PERMANENT MAGENTA
▨	INDIAN YELLOW	■	HELIOS PURPLE
▨	CADMIUM ORANGE	■	COBALT VIOLET
■	CADMIUM SCARLET	■	WINSOR VIOLET
■	CADMIUM RED	■	FRENCH ULTRAMARINE
■	WINSOR RED	■	COBALT BLUE
■	ALIZARIN CRIMSON	■	PHTHALO BLUE
■	PERMANENT ROSE	▨	CERULEAN BLUE
▨	RAW SIENNA		

This is one of four starts that I painted based on the above setup. I used unsized Fabriano 140-pound cold-pressed paper, which I positioned upright on an easel during almost the entire process. In order to give myself an approximate indication of where they would go, I lightly sketched in both the vase and the white flowers, exaggerating the size of the latter slightly. I treated the stargazer lily as I would a white flower because it is edged in white.

After loading a No. 8 round brush in cerulean and cobalt blue, I painted in this stately blue delphinium while squinting at the outside shape to simplify its form. I added and modified the color as I moved down the stem, washing the brush out between color changes. I combined the flowers in various groupings and shapes by overlapping them, letting the colors flow into each other, and continuing to change the color and value as I advanced.

After I was satisfied with the initial progress on the delphinium, I painted the center of the daisy with a mixture of raw sienna and cadmium orange. Next I worked on the Queen Anne's lace using a very watery mixture of jaune brillant, raw sienna, and cobalt violet. I then moved on to the purple delphinium, using a mixture of Winsor violet and cobalt blue. For the greens—as always—I switched back to my blues and yellows, but with no set formula.

For the off-white rose I concentrated on very soft colors, mainly using a watery mixture of jaune brillant and Indian yellow with touches of permanent rose, blending and using stronger color toward the center, wiping the brush frequently to remove excess color and water. I then proceeded to add blue-green to some of the leaves, varying their values and overlapping their shapes. Although the setup included a white daisy and a magenta cosmos next to the red rose, I decided at this point to eliminate them.

The red rose was a challenge because of its many petals. Still squinting to reduce form, I used alizarin crimson and cadmium red to paint connecting, overlapping oval shapes, softening here and there, using only water with a 3/4-inch Winsor & Newton flat brush. I paid particular attention to the outside edges, keeping their values dark. By mixing the color on the paper rather than on the palette, you can achieve a subtle blend and variety of color. Usually I paint in groups or clusters, creating a range of hard and soft edges by letting a section dry, returning later to add or subtract.

I began the stargazer lily by drawing it with exaggerating curves, then covered the stamens and edges of the petals with liquid frisket. Using a round brush loaded with alizarin crimson, I painted it from the inside out, then pulled the paint toward the edges of the petals with a 3/4-inch flat brush loaded only with clean water. I then added soft and subtle accents while the paint was still slightly wet.

I next worked on the leaves nearest the lily using a mixture of cobalt blue and raw sienna, then on to the blue hydrangea with a mixture of cobalt blue and Winsor violet. I gave careful consideration to the shapes of all the hydrangea's outside edges, exaggerating all its nuances so as not to make it look like a cheerleader's pom-pom. After first making sure that it had dried, I returned to the off-white rose to add some negative shapes using Indian yellow, cadmium scarlet, and jaune brillant. At this point I took a break from this painting to begin another version of the same bouquet.

When I resumed work on this painting, I continued to soften some of the edges of the previous washes with the newer ones while studying the entire bouquet. (Note that I painted in some darker values as guides.) Then I moved around to different areas, either to establish negative space or to sketch in shapes with my brush. I did not concern myself at this stage with getting the colors exactly right. For example, although I realized that both zinnias looked too soft even as I was painting them, I knew that I could punch them up later. Taking the dark value of the vase into consideration, I established the darks in the flowers for balance. I then slowly pulled out some of the green shapes using various mixes of phthalo blue with Indian yellow and burnt sienna.

I developed the zinnia near the center of the bouquet with washes of Helios purple, permanent magenta, and cobalt violet, and the one on the right with Indian yellow and Winsor red. I painted in the stem of the cosmos gliding forward in the pictorial space with cobalt blue and Indian yellow, then continued with its flower using a juicy mixture of cerulean blue and permanent magenta. When I stepped back to evaluate my work, I thought I might have defined the flowers a little more than I usually like, but I knew that the value of the vase would help to balance the painting. Since I had only to add the vase and fabric in order to complete this painting, I decided at this stage to work on another.

When I returned to this painting, my task was to sketch in more of the vase and the direction and values of the folds of the fabric. I taped tracing paper to the lower part of the painting and lightly sketched with a No. 2 pencil, which enabled me to make corrections without damaging the surface of the paper. To work out patterns within the folds of the fabric, I looked for shapes of letters there: Vs, Ws, and Ss. I tried to capture the sideways S starting from the lower right and leading to the vase, then moving out again to the middle left. Before removing the tracing paper, I marked three 1-inch Xs on both the tracing paper and the watercolor paper so that I could easily line them up again later.

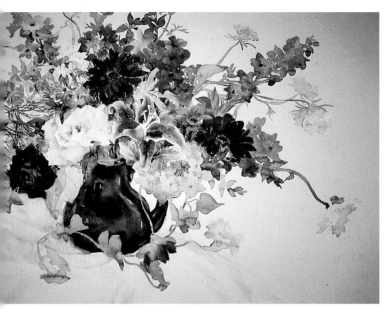

Before beginning the vase, I turned the painting so that it was positioned vertically on the easel, then covered the edges of the bouquet nearest the vase with liquid frisket to protect them from the dark paint. Starting at the top, I lay in a wash of French ultramarine and Winsor violet. To reflect a change in hue, I wiped the brush clean and loaded it with cobalt blue, then dabbled on some French ultramarine and Winsor violet, and lifted out the highlights while the paint was still wet. I didn't paint the vase as dark as it actually is because I didn't want it to dominate the painting or create a dark hole in the center of the composition. To define the folds in the fabric, I first placed the painting on the easel at a 20-degree angle, then used very light values of cadmium lemon, cadmium orange, cobalt blue, and permanent rose. I started the folds to the right of the morning glory with cadmium lemon, then continued them with cobalt blue, thereby creating the illusion of reflected light. After assessing my work, I strengthened some folds and softened others. Finally, I covered the edges of the flowers against the background with liquid frisket, then lay in the background using cobalt blue and cadmium orange, arbitrarily indicating shadows. Note that it may take three or more applications to intensify the background color adequately.

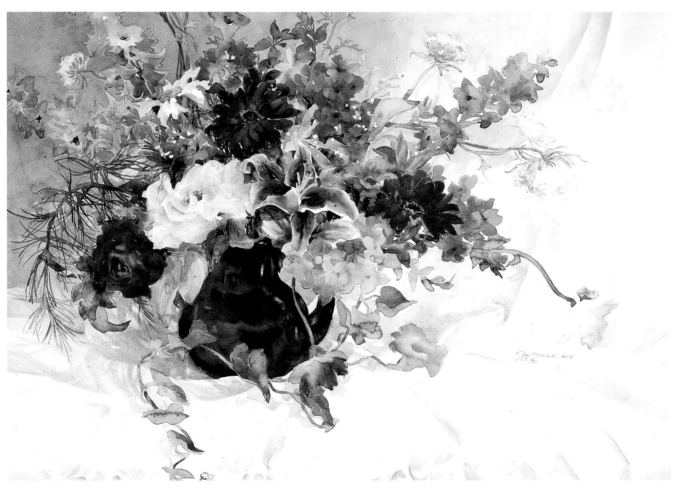

COBALT BLUE VASE
Watercolor on 140-lb. Fabriano cold-pressed. 22 x 30 inches (55.9 x 76.2 cm). Collection of the artist.

DEMONSTRATION: GARDEN GATHERING

Since the bouquet was still fresh, I used the same setup for this painting—my second start—that I had arranged for *Cobalt Blue Vase*. When I began I relied very little on what I had done in the first painting, and drew inspiration instead from the strength of and similarities among the round shapes of some of the flowers. Parts of the original bouquet had died, so I added new flowers and recycled others such as the daisies. This was relatively easy to do, as the arrangement was composed entirely of overlapping forms. I painted *Garden Gathering* more slowly than *Cobalt Blue Vase* because I continually fine-tuned the composition as I worked, but I felt more comfortable about implementing some of the finishing touches earlier than I usually do because I was somewhat familiar with my subject. I used the full palette for this painting.

As I did in *Cobalt Blue Vase*, I started at the top of the bouquet with the Queen Anne's lace, using just a touch of a thinned mixture of jaune brillant and permanent rose for these delicate flowers.

After establishing the size and shape of the rose, I sketched in the daisy alongside it. I returned to the rose to deepen its color, adding Winsor violet to the alizarin crimson/Helios purple mixture. I painted in the mass of greens in the lower left, adjusting their shapes, sizes, and colors as I proceeded. I then lay in some White Mask to begin the baby's breath.

To paint the rose, I loaded my brush with a mixture of Helios purple and alizarin crimson, occasionally using the white of the paper to indicate the edge of an overlapping petal. As I worked, I noticed that the rose had opened, so when I reached its center I rinsed the brush, then loaded it with Indian yellow. I was careful to leave a slender margin of white at its top so that the red wouldn't run into the yellow.

Changing to a mixture of cobalt blue and Indian yellow, I painted in the stems and the fern in the lower left of the composition, then increased the value of the leaf above the rose.

At this point I arbitrarily decided to move some of the flowers around, and to exaggerate the sizes of others. I grouped the petals of the zinnias and the daisies around their centers to create interest and add character.

When I add new flowers to a bouquet in progress that I'm not sure will fit, I simply hold them up to the area in the painting where I think I want them, just to see how they look. On impulse, I added a pale pink-and-white rose to the upper right-hand corner, but I immediately disliked what I had done. I first wet the area lightly with a natural sponge, then picked up some of the pigment with a dampened round brush. Because the paper is unsized 140-pound Fabriano cold-pressed, I couldn't scrub too long or too hard. I felt grateful that the color was light in value, so I could overpaint the remaining traces of color.

After the area where I attempted to add the light pink rose dried completely, I added a deep red dahlia in alizarin crimson with a touch of Winsor violet with a center of cadmium orange, quickly dashing in the values I want. At this point, the "puzzle" of the painting was close to a solution, and while softening edges here and there I began to plan its finish.

PALETTE

- CADMIUM LEMON
- JAUNE BRILLANT #2
- INDIAN YELLOW
- CADMIUM ORANGE
- CADMIUM SCARLET
- CADMIUM RED
- WINSOR RED
- ALIZARIN CRIMSON
- PERMANENT ROSE
- RAW UMBER
- RAW SIENNA
- BURNT UMBER
- BURNT SIENNA

- PERMANENT MAGENTA
- HELIOS PURPLE
- COBALT VIOLET
- WINSOR VIOLET
- FRENCH ULTRAMARINE
- COBALT BLUE
- PHTHALO BLUE
- CERULEAN BLUE
- COBALT TURQUOISE
- PHTHALO GREEN
- PERMANENT GREEN LIGHT #1
- PAYNE'S GRAY

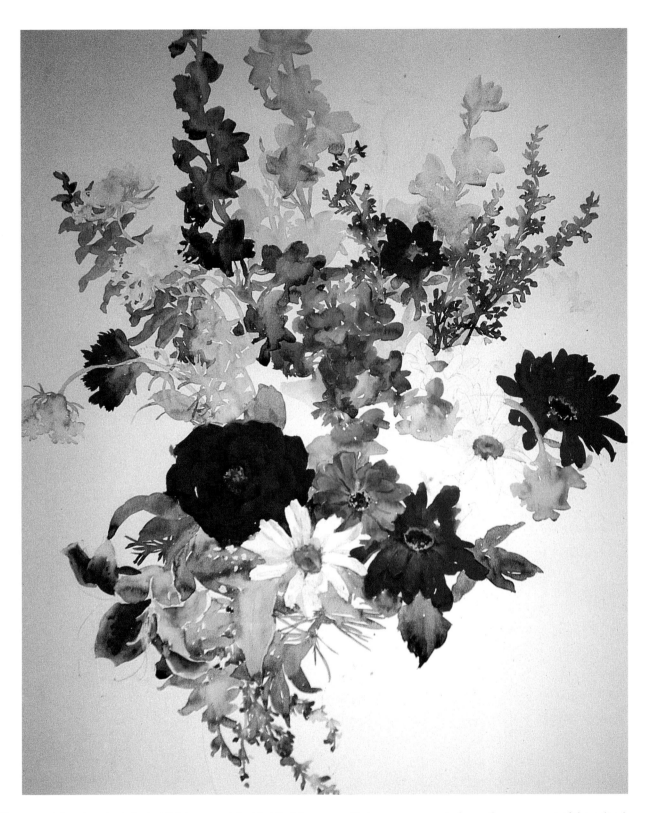

After several days I evaluated what I'd done, and decided that the painting needed some finishing touches; that is, strengthened values and softened edges. I realized that I would like to continue the daisies around the left side of the rose in a more or less circular pattern.

After incorporating most of the flowers, I covered their outside edges with White Mask, then set aside the painting to dry completely.

To increase my control over the movement of the color, I worked on a flat surface while laying in the soft wet-in-wet background. Before adding color, I first wet the paper with a dampened 3/4-inch Winsor & Newton flat brush, working on one section at a time. I'm able to do this because parts of the painting extend beyond the frame of the paper. When adding color, I worked primarily with greens, blending them with various colors from the flowers as I suggested faint shapes.

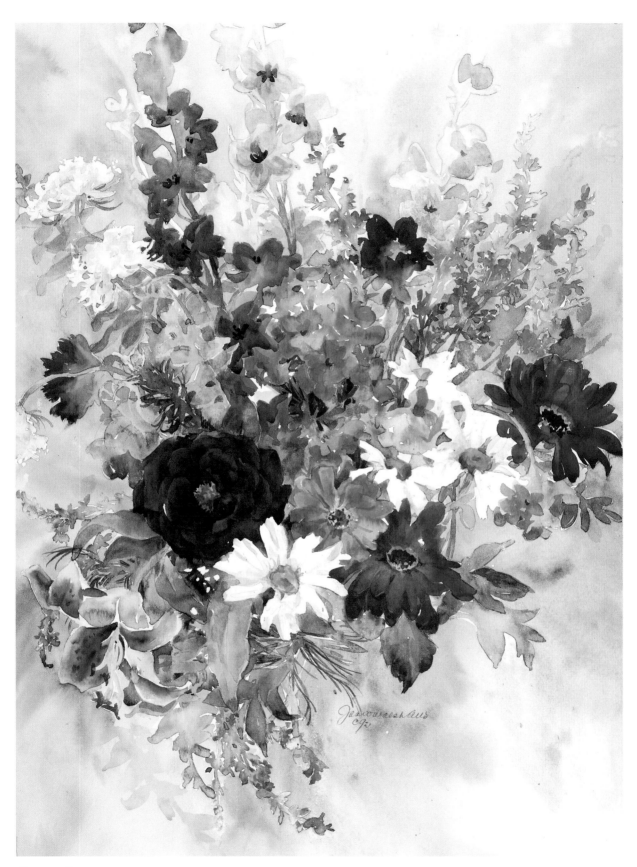

Garden Gathering
*Watercolor on 140-lb. Fabriano cold-pressed. 30 x 22 inches
(76.2 x 55.9 cm). Collection of the artist.*

LEARNING FROM FAILURE

I find that my students need to be reminded periodically that their paintings can't all be successful. Every painting offers a different set of challenges—even when you're working from the same setup—and an opportunity to learn from the experience, regardless of its outcome. For instance, I based four paintings on the setup that I had used for *Cobalt Blue Vase* and *Garden Gathering,* two of which I felt were utter fiascoes. I rejected one (right) because the pattern of the bouquet looked as spiky and rigid as a stretch of railroad track, and the positions of the individual flowers just didn't seem to work. On the other (left) I got carried away with the number of blue delphiniums I included; I was seduced by their beauty into thinking that more of them would only enhance the painting. I sometimes keep my less successful efforts so that I can refer to them in the future as examples of what *not* to do. Learn to appreciate your failures—they'll contribute immeasurably to your ability as an artist.

Although these two paintings, which I had also based on the setup I used for *Cobalt Blue Vase* and *Garden Gathering,* ended up on the discard pile, my efforts were not in vain. Failure can be a wonderful teacher—if you're complacent, you can't improve or grow as an artist.

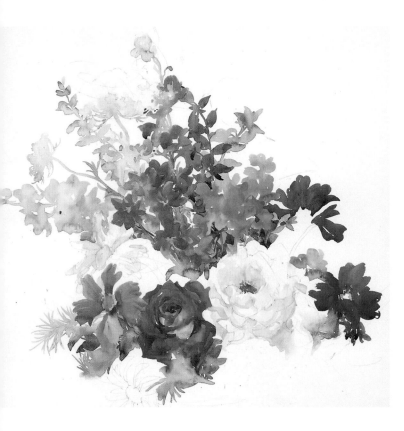

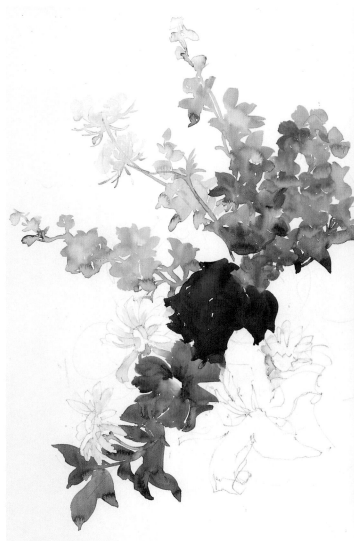

DEMONSTRATION: MADGE'S CLAY POT

This painting reflects techniques that are covered in Chapters 6 and 7: saving and painting whites, and rendering fabrics and backgrounds. I started it as part of a workshop demonstration through which I aimed to depict a grouping of multipetaled flowers simply and directly. It's also a good example of how I put a setup together after establishing the central motif.

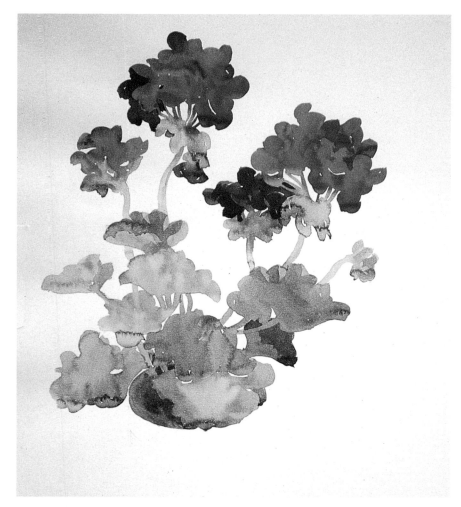

This painting was the outcome of the demonstration, during which I had painted the leaves and stems of the geranium as growing in a container. This left the painting in good shape visually, making it easy for me to continue later.

PALETTE

- INDIAN YELLOW
- CADMIUM ORANGE
- CADMIUM SCARLET
- CADMIUM RED
- WINSOR RED
- ALIZARIN CRIMSON
- PERMANENT ROSE
- RAW SIENNA
- COBALT VIOLET
- WINSOR VIOLET
- FRENCH ULTRAMARINE
- COBALT BLUE
- PHTHALO GREEN

Back at the studio I made final decisions about the container, the fabric, and the other elements I wanted to include. Because I liked the way the colors looked on the white of the paper, I decided to continue with warm and cool reds throughout.

In addition to roughly sketching in the container, I also made some indications for fruit.

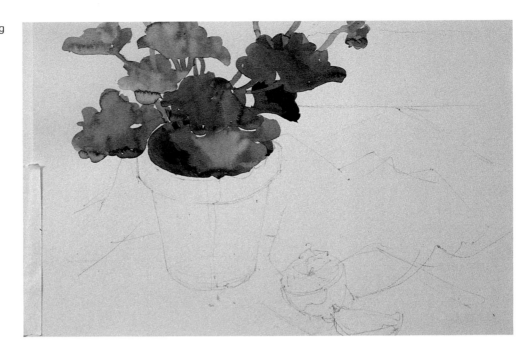

Mixing French ultramarine, burnt sienna, and cadmium red directly on the paper, I lay in the first wash for the clay pot in an S stroke. I enhanced the texture produced by the S stroke by using a thicker consistency of paint than I normally do. I wasn't quite happy with the container at this stage, so I added another layer of paint after the first had dried.

I then taped a piece of tracing paper over the painting and started to work out the pattern of the folds in the fabric, making many changes as I worked. (If I'm not pleased with what seems to be emerging in a tracing, I'll discard it and start again, or simply erase parts of it and continue to work on it until I'm satisfied.) After I had finished, I transferred the tracing to the paper.

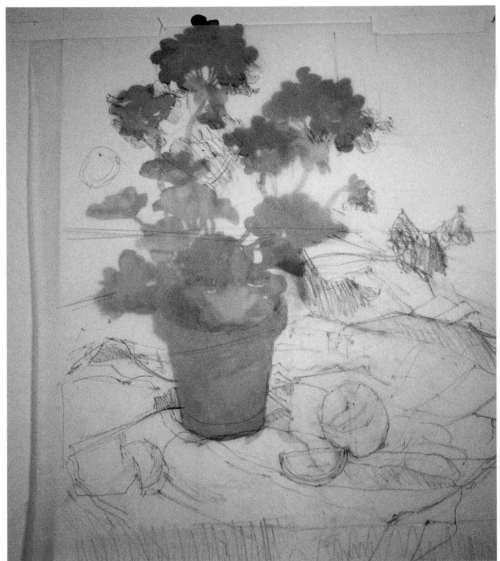

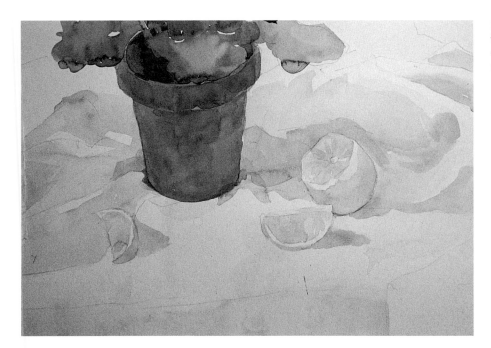

I began to paint in the rhythm of the folds in the fabric, using the sketch only as a guide and even at this stage making changes as I worked.

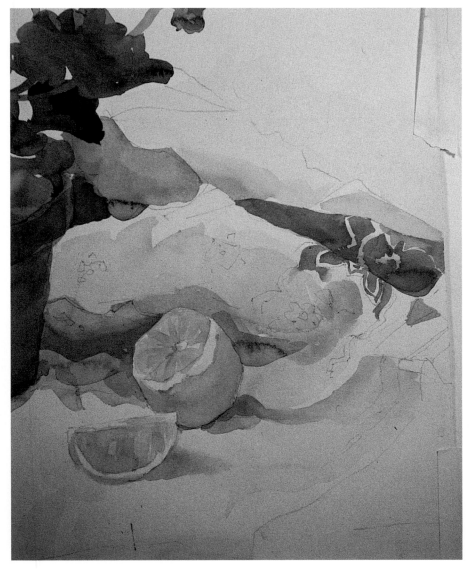

I had no intention of painting every detail of that very busy pattern—only enough to record my impression of it adequately. As shown here, the fabric was almost finished.

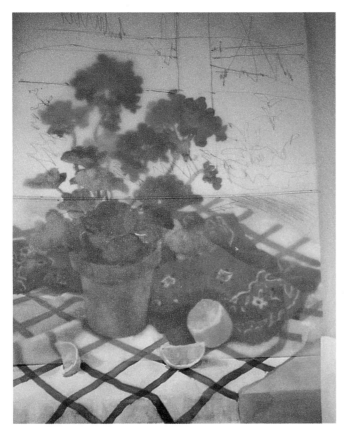

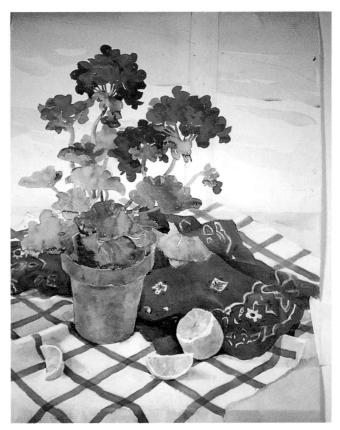

As I worked I was inspired by a heavy snowstorm: I speculated that the white-and-blue patterns in the snow would complement the arrangement beautifully. A few black-and-white Polaroids confirmed my hunch, and my decision about the background was made. I placed a piece of tracing over the painting and made some very rough pencil sketches of a landscape to determine which approach would work best with the composition. Because the other elements in the painting are so strong, I felt that the background should be painted as simply as possible.

Before painting the sky and the hilltops, I covered the flowers and the windowpane with White Mask. I then extended the subtle patterning of the open sky down toward the flowers while gradually decreasing the values of the colors.

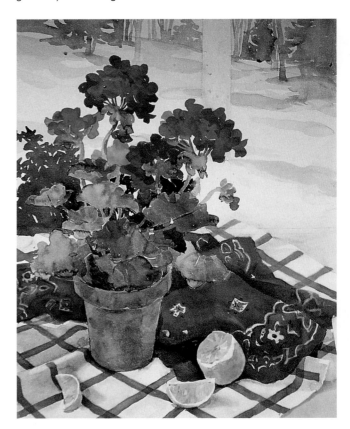

I treated the band of foliage between the geraniums and the background as a generalized arrangement of leaves. The trees were painted even more subtly and abstractly in order to create a sense of three-dimensional space. I then added soft red to link the background with the principal foreground colors.

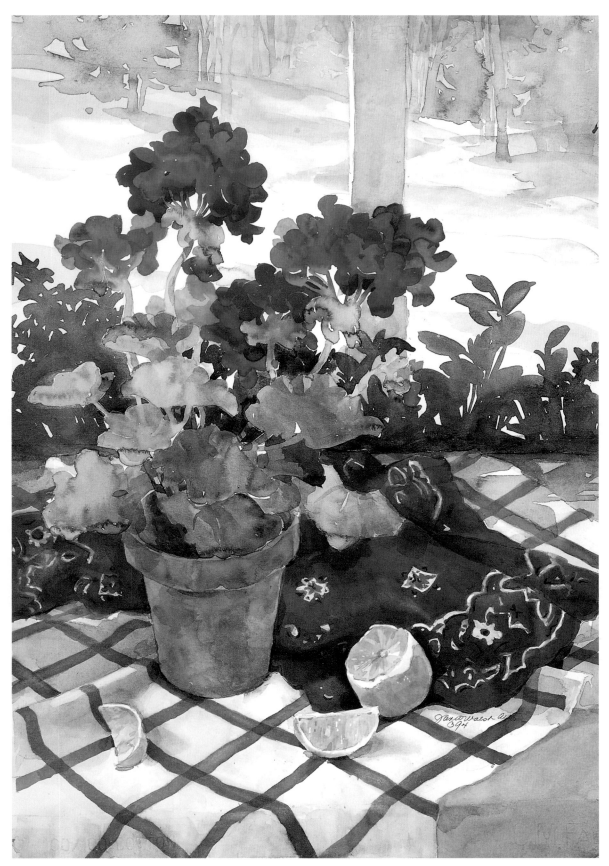

MADGE'S CLAY POT
Watercolor on 140-lb. Arches cold-pressed. 30 x 22 inches (76.2 x 55.9 cm).
Collection of the artist.

OTHER APPROACHES TO STILL LIFE

Although my approach to still life is primarily realistic, occasionally I like to strive for a different visual direction by greatly simplifying the forms and analyzing the value patterns of some traditional subjects. The paintings shown below and opposite were based on a series of drawings and collages, through which I developed the compositions over a period of a few years. While simplifying the intricate shapes of the sunflower's leaves, however, I wanted to retain their

energy, which I felt was central to the character of the painting. I painted them in a three-value range, gradually varying the greens to yellows, oranges, and reds. The simplicity of the flower and foliage forms provided a suitable backdrop for the implied activity of the birds and cats. I was fortunate that all my models were indigenous to my garden: I grew the sunflowers, which enticed the crows, which in turn attracted my two cats, Spunky and Lardo.

PECKING ORDER
Watercolor on 140-lb. Fabriano cold-pressed. 38 x 26 inches (96.4 x 66 cm). Awarded the American Watercolor Society Bronze Medal of Honor. Collection of Mr. and Mrs. Theodore Gore, Williamsburg, Virginia.

WAITING GAME
Watercolor on 140-lb. Fabriano cold-pressed. 35 x 26 inches (89 x 66 cm). Awarded the American Watercolor Society Edgar A. Whitney Award, the Allied Artists Creative Watercolor Award, and the Hill Memorial Award of the Catherine Lorillard Wolff Art Club. Collection of Mr. and Mrs. Theodore Gore, Williamsburg, Virginia.

ANALYZING VALUE AND COLOR

Similar in style to the paintings shown on the previous two pages but more traditional in terms of their still life elements, the sketches and the final paintings on these two pages and the two following—*Bounty* and *Fruits of Labor*—clearly reflect a process of continuing development and analysis.

When arranging the setups I concentrated on overlapping and contrasting shapes and creating groups of dark and light forms. Note in both images the geometric shapes, stylized colors, and rhythms created by the foliage. After completing preliminary studies of their individual elements, I developed black-and-white value sketches, which I used to assess the merits of the composition and determine whether any adjustments were needed. (Note that in the normal course of events, I might make three or four sketches before I'm satisfied with the balance of the values and the weights and flow of the shapes.) Using the black-and-white sketches as guides, I prepared color planning sketches, whose solution required several progressive revisions. I used a grayed palette to ensure that the colors were in harmony. I then enlarged the color sketch so that I could address the subtleties that occurred within each shape while attempting to retain the values established in the black-and-white sketch.

I painted both pieces on 300-pound double-elephant paper (a very large sheet about 26 x 40 inches) that I had first stretched on a board. I lay in several glazes—some areas have ten or more—letting each dry before applying the next. Each painting evolved slowly, taking six to eight months to complete. Although its aim is the reduction and simplification of form, this approach to still life painting can be painstaking and time consuming.

However, the lessons learned in how to work with color and shape can contribute immeasurably to a looser, more intuitive style of rendering.

Black-and-white value sketch and color planning sketch for *Bounty*.

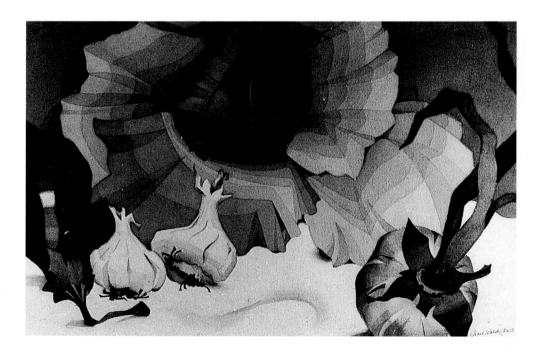

Compare this black-and-white reproduction of *Bounty* to the initial black-and-white value sketch.

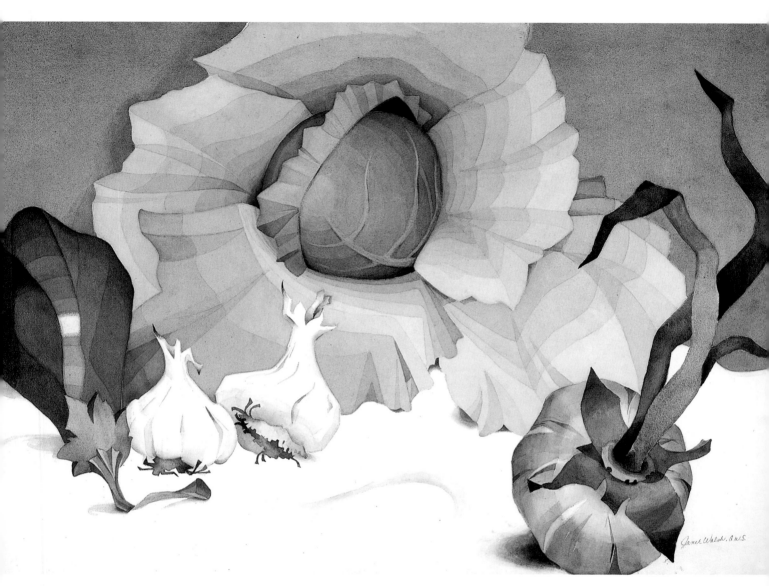

BOUNTY
*Watercolor on 300-lb. Arches cold-pressed. 26 x 40
inches (66 x 101.6 cm). Awarded the Esposito Prize at
the Adirondack National Exhibition. Collection of Mr.
and Mrs. Theodore Gore, Williamsburg, Virginia.*

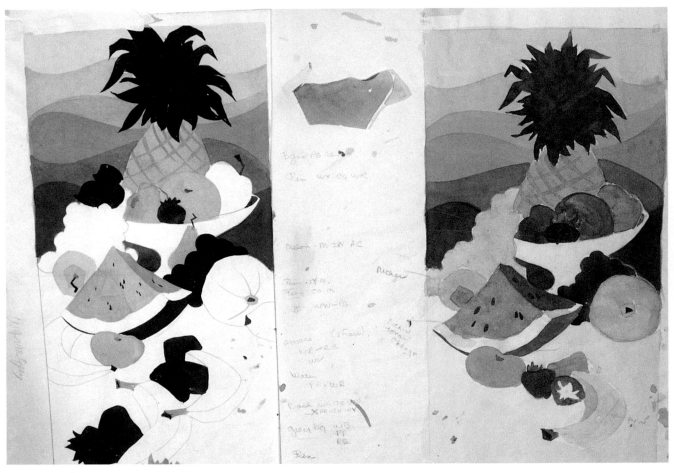

Black-and-white value sketch and color planning sketch for
Fruits of Labor.

Compare this black-and-white
reproduction of *Fruits of Labor* to the
initial black-and-white value sketch.
The vertical, warm-toned composition
creates a lively, rhythmic feeling.

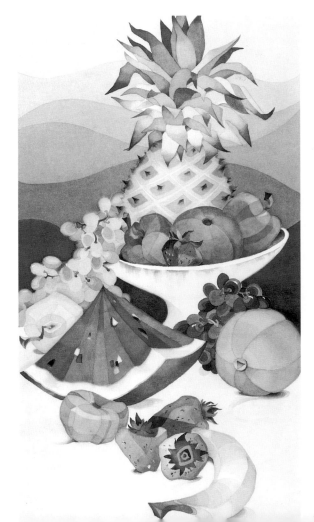

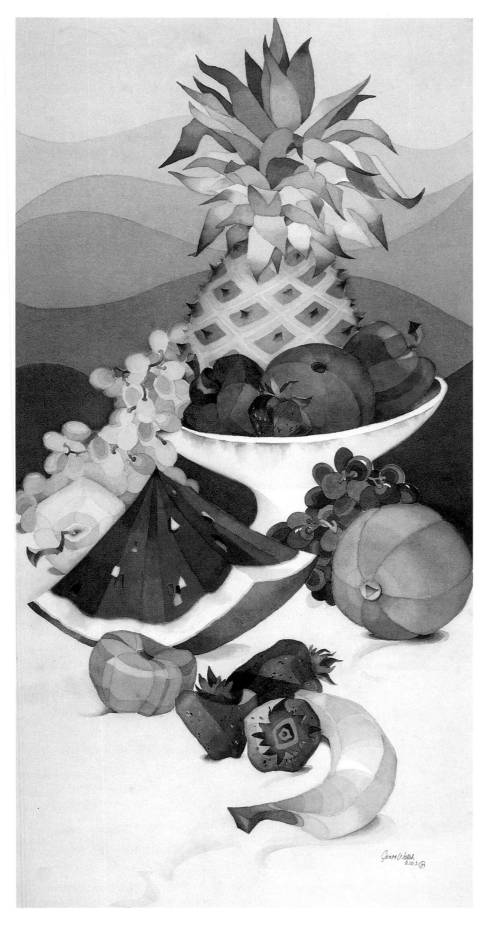

FRUITS OF LABOR
*Watercolor on 300-lb. Arches cold-pressed. 40 x 26 inches (101.6 x 66 cm).
Collection of Mr. and Mrs. Theodore
Gore, Williamsburg, Virginia.*

CHAPTER NINE

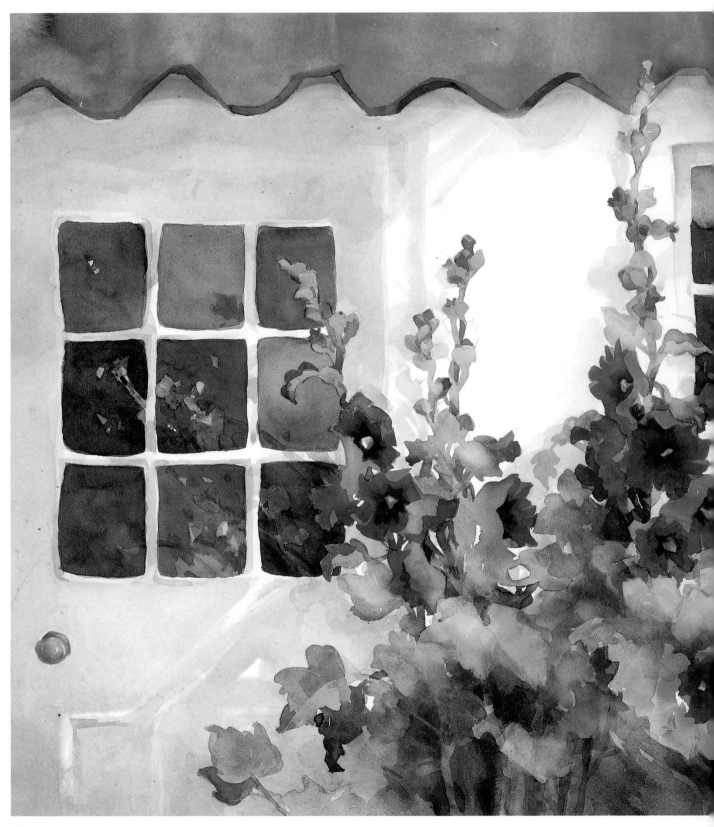

HOLLYHOCKS
Watercolor on 140-lb. Lanaquarelle cold-pressed. 22 x 30 inches (55.9 x 76.2 cm).
Collection of the artist.

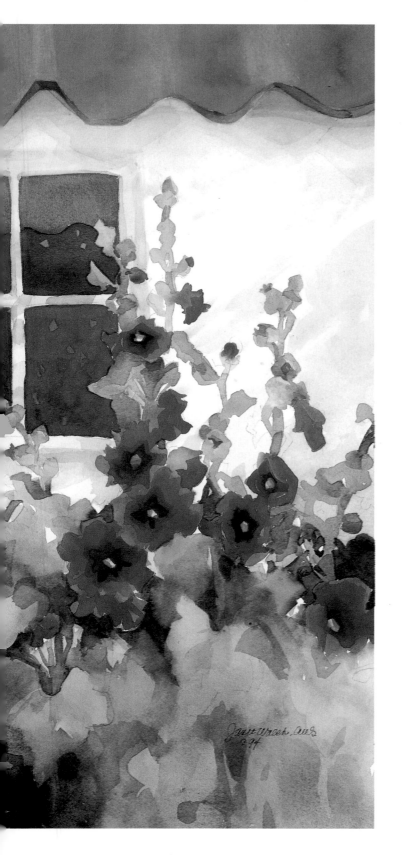

Plein Air Painting

While my mode of expression is principally representational, my work is intuitive rather than strictly realistic, in that I base most of my creative decisions on my feelings about a subject. My explorations of nature, made while sketching, painting, gardening, and traveling, continue to be a boundless source of inspiration, and have fostered in me an appreciation for what I have come to recognize as an ongoing creative alliance. I am also interested in investigating the contrast between nature and architectural form, whether the walls and windows of a cottage in a garden or the outline of a cathedral against a magnificent sky. If you cultivate the right attitude, the primary difference between painting still lifes in the studio and painting in outdoor light, or plein air painting—having to reckon with changing weather, light, and seasons— can be exhilarating.

CAPTURING THE ESSENCE OF A SCENE

Since a plein air setup can't be physically rearranged, the process of finding an underlying, meaningful structure becomes even more important. Making careful observations while you're simply taking a walk can help increase your awareness of a wide range of visual associations. When I happen upon a place that interests me visually, I immediately evaluate the scene from several angles as I begin to record the essential information. Sometimes I set aside my sketches and rough starts for a day or two so that I can give my ideas a chance to develop. In this way, my sketchbook becomes much more than a digest of reference material; it's how I familiarize myself with the nuances of a specific location.

The task of composing a painting is very similar to the process of writing a book, in that the content of both must be carefully edited so that the ideas are conveyed effectively. Before I begin painting an outdoors scene, I think about what attracted me to the site, as well as my feelings about it. This helps me define the painting's emphasis, which might be the mood of the scene, the patterns of the shadows, or the textures of the individual elements. As I work, I make decisions about adjusting the shapes, configurations, and positions of the various elements, such as changing the line of a roof or the height of a tree. I experiment with several different formats—small, large, horizontal, vertical, rectangular, square—and viewpoints—from a distance to close-up, and many in between.

ORGANIZING SPACE

Also important is the way that space is used within a format, and the relationships between the various masses and the overall space. Avoid dividing the image into halves, as this approach usually does little to enhance either the subject or the format. When I compose my florals in a horizontal format, I tend to locate the focal point toward either the right or the left. However, you should also resist positioning all your elements on one side of the image, as well as imposing uniformity on every aspect of the image in an attempt to achieve balance. For example, don't paint everything in the same color, visual weight, or size, as this will virtually guarantee monotony. One of the more traditional ways of organizing the painting space is to divide the paper into thirds, both horizontally and vertically, then to choose one of the points of intersection as the focal point for the painting. These and other rules governing composition, if followed to the letter, can be more of a hindrance than a help. It's best to remain flexible and experiment.

The spacing among elements must also be considered. In painting, the term *movement* is used to refer to the visual progression from one area to another, either through the distribution of space or the linkage that is established among masses of similar values. Movement in a painting leads the viewer through the image to the focal point. When patterns of movement are repeated, rhythm is created. Movement can be expressed through line, shape, form, and/or color.

INTERPRETING LIGHT AND COLOR

In contrast to painting indoors, painting on location offers artists an infinite variety of light effects. The visual differences among the various atmospheric conditions influence the way that color is perceived. Patterns of sun and shade also affect the appearance and depiction of color.

Careful observation is the key to learning about how the quality of light influences the way that you see color. When you look at a meadow, notice how many shades of green there are, as well as the spectrum of colors within the various greens. Don't simply paint a tree trunk brown; look for the subtle nuances within its color before you lay in your first wash. These details of perception will stamp your vision of a scene with your creative seal.

ST. PAUL-DE-VENCE #2
Watercolor on 140-lb. Fabriano cold-pressed.
30 x 22 inches (76.2 x 55.9 cm). Private collection.

On my first visit to St. Paul-de-Vence, a picturesque fortified village on a hilltop outside of Nice, France, I was enthralled by the profusion of flowers. Anything that could be used as a container held flowers in full bloom. I was initially attracted to this scene by the white pattern in the flowers. I simplified this scene to a great extent by breaking down the pictorial space into inverted K shapes. I painted the flowers on the step paler in color and lighter in value so they would not compete with the dominant floral mass, which I painted in a triangular configuration. I treated the windows as part of the design, adjusting their color and value to enhance their role in the image. The subtle white patterning leads the eye through the painting, up the steps, and to the door, creating a directional contrast. I would like to paint other versions of this scene, in which I will explore textural contrasts and patterns of sun and shade.

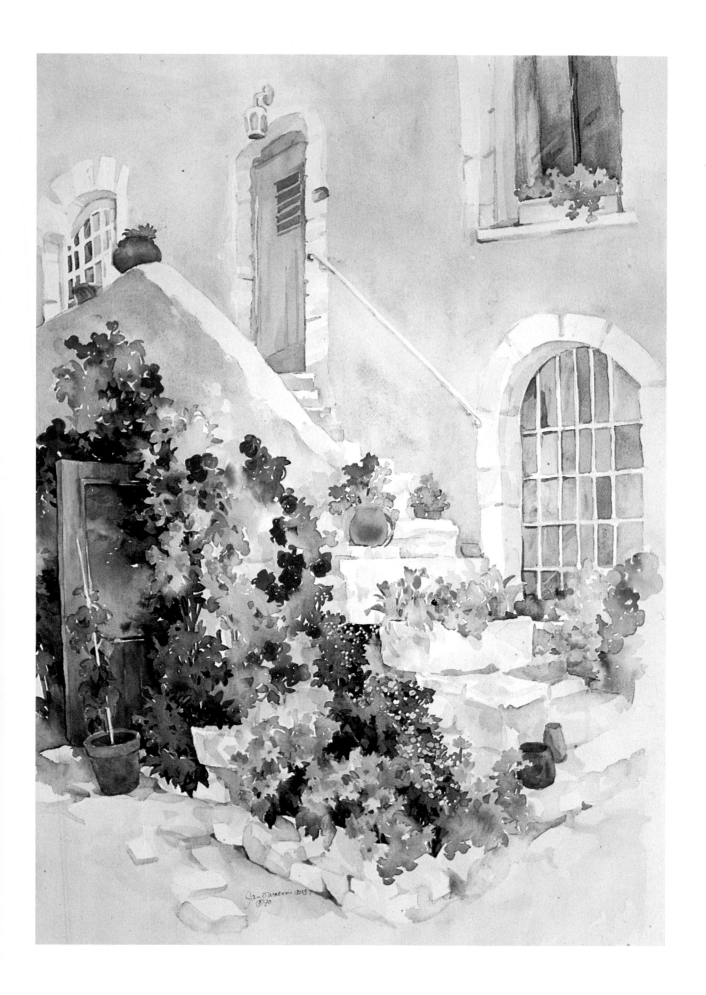

WORKING WITH PHOTOGRAPHS

Painting on location and using a camera go hand in hand. While I use my sketchbook to explore my feelings about the subject, I use my camera to document the details of a scene's various elements, such as pattern and texture. I also strongly believe that the visual experience obtained while taking photographs helps to strengthen intuitive composition.

Make sure that the photographs you paint from are your own. You shouldn't paint a scene that you haven't experienced yourself. If you feel overwhelmed by the information you've documented in a photograph, start by studying a small section of it. Regardless of how you use a photograph, don't rely too heavily on what might at first seem to be the "truth" of the scene. When you review your photographs or slides, ask yourself a few critical questions: How can I improve my visual choices? Would the image benefit from an adjustment of the horizon line? Does the composition look balanced? The adjustments you make in response to your feelings about it are the essence of your art.

TRANSFERRING A SKETCH TO PAPER

Once you've decided on the format and completed your sketch, you will need to transfer your work to a sheet of watercolor paper while maintaining its original proportions.

To enlarge your sketch, lay a ruler or straight-edge from the lower left-hand corner to the upper right-hand corner of your sketch.

The base line for determining the height and width for your enlargement is where the dissecting diagonal line falls outside your sketch. To enlarge your sketch proportionally, draw vertical and horizontal lines from any point on this line.

To transfer the image, very lightly mark a grid of equal increments over the sketch, then do the same on your paper, in an area that is proportionally consistent with the area of the sketch. The area of the image in each box of the grid should correspond to the one on the paper. For more detailed work, the sections of the grid can be broken down further.

If this is your first attempt at transferring a sketch, you might want to trace it by working over a light box. Some artists use an overhead projector to project the image onto the paper so that they can establish its major sections before adding details. Occasionally I use a photocopier to enlarge the image, and as this tends to distort it I usually end up refining it as I transfer it.

By simply drawing a diagonal line through a sketch, you can determine an enlarged size that is proportionally correct. Any of the boxes denoted by the dotted lines above dotted line are proportionally the same as the small sketch.

A grid, drawn over your original sketch will help you place elements in the enlarged version, if you draw a corresponding grid on the new surface.

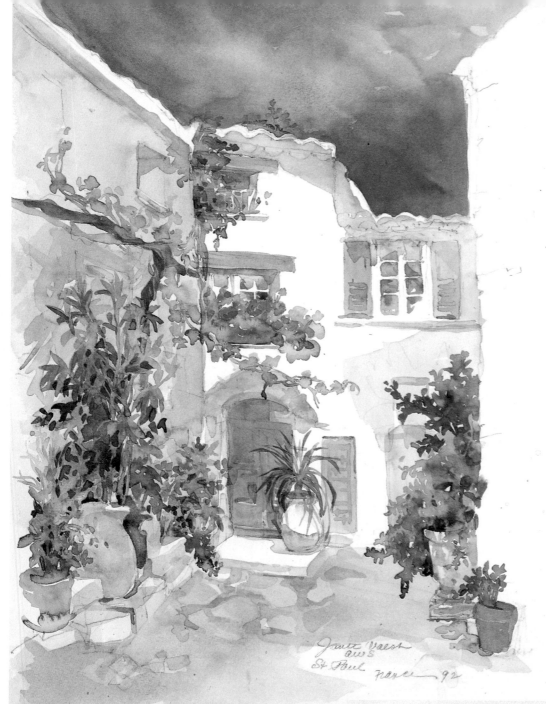

The Courtyard
Watercolor on 140-lb. Fabriano cold-pressed. 30 x 22 inches (76.2 x 55.9 cm). Collection of the artist.

The angular shape of the sky against the buildings drew me to this site during my second visit to St. Paul-de-Vence. There was a lot of cloud cover, so I took a few Polaroids to improve my view of the light-and-dark pattern in the sky. I lightly sketched in the buildings, eliminating or modifying their less important elements. I treated both the red tile roof and the wall on the right as basic shapes, noting very little detail. I exaggerated the foreshortening of the floor to enhance depth. The first element I painted was the pattern created by the intermingling of sun and shade, mixing my colors directly on the paper. I started at the top of the image with cadmium orange and raw sienna, working progressively cooler as I approached the base of the courtyard. Although I painted the foliage very directly and simply here, I would like to simplify it even further if I paint another version of this scene.

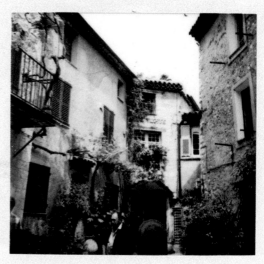

DEMONSTRATION: COFFEE BREAK

I came upon a chap having what I thought was his morning coffee in Whitby, England, although now I realize he was probably drinking tea. I was astounded by the relationships among the shapes, especially the one between the workman and the flower box. I rearranged positions of the workman and the windows so as to give more variety to the negative space and to improve the balance of the image.

Since this painting is composed of simple, rectangular shapes on a white background, it was easy to explore other possibilities by moving the elements around and otherwise experimenting with them in a few thumbnail sketches.

I worked out the drawing on tracing paper, which I then transferred to watercolor paper. To begin the painting, I applied an extremely light wash of a very watery consistency over most of the paper, using the white of the paper to make some of the architectural forms stand out. Note the variety of whites in the window, which I tried to subtly differentiate. I used a number of shades thinned to the values shown in the color chart for painting whites (see page 80) to do this, including cadmium lemon, raw sienna, and cobalt violet.

At this stage I continued to mass in the patterns of the windows and door. I handled the workman as one shape, starting at the head (where I repeated the color I used for the door), continuing down into his flesh, then switching again to his clothing. My first attempt at laying in the shadow patterns of the window curtains was much too dark, so I lifted out some color with a natural sponge and facial tissue in order to preserve the feeling of a bright cheery day.

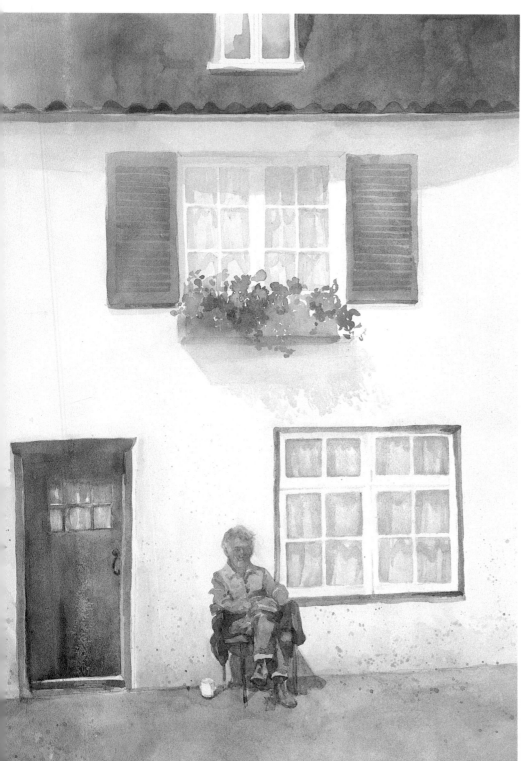

COFFEE BREAK
Watercolor on 140-lb. Fabriano.
23 x 17 inches (58.4 x 43.2 cm).
Collection of the artist

I lay in the negative shapes of the shutters before painting the overall wash. The window curtain pattern is varied throughout, which gives the painting some sense of movement. I painted the flowers in the window box and the shadow beneath them as a single shape, adding some negative shapes here and there. Although the tile roof is also treated simply, it's an important part of the composition.

DEMONSTRATION: SIESTA

The harsh hills off the coast of southern Spain hold many wonders for the adventurous at heart. One of the many marvels of this region is Castillo San Rafael, an isolated castle two miles from the tiny fishing village of La Herradura. Built by the Phoenicians almost 3,000 years ago and used for centuries as an outpost protecting the road to Grenada, today it is a modern oasis frequented by small groups of artists. On my first visit to San Rafael I was immediately attracted to a scene consisting of a graceful reed roof over a small patio. The shadow pattern cast by the roof was truly awe inspiring.

This painting is a prime example of my treatment of shadow patterns and reflected light within masses. As usual, I eliminated a lot of detail when sketching in the principal shapes, and simplified the hanging reeds in particular. I probably put more thought into how to establish this first pattern, and how various areas would be connected through color linkage, than I did for the entire scene.

Starting at the top of the paper, I painted the reeds of the roof and its shadow as one shape. I lay in the roof with a warm color, providing a strong contrast with the sky. I then adjusted its color toward cobalt violet as I approached the wall. To dramatize the receding roof and the reflected light, I adjusted the color once more to an orange-yellow, then only yellow near the bottom of the shadow. I lay in a cooler color in the shadowed area to the left in order to de-emphasize it.

After the first wash, I pulled out some of the darks, which not only served as a guide for my darkest value, but started to establish a pattern to lead the eye through the painting. White mask has been applied to the floor with a spray mister to help create a rough texture that will contrast with the white wall. Color was then randomly applied to the floor. The colors repeated those found in the beams and the door. Areas were further defined in a simple manner, and the area at left was treated as one shape, even though it contains a barrel, foliage, and a tree.

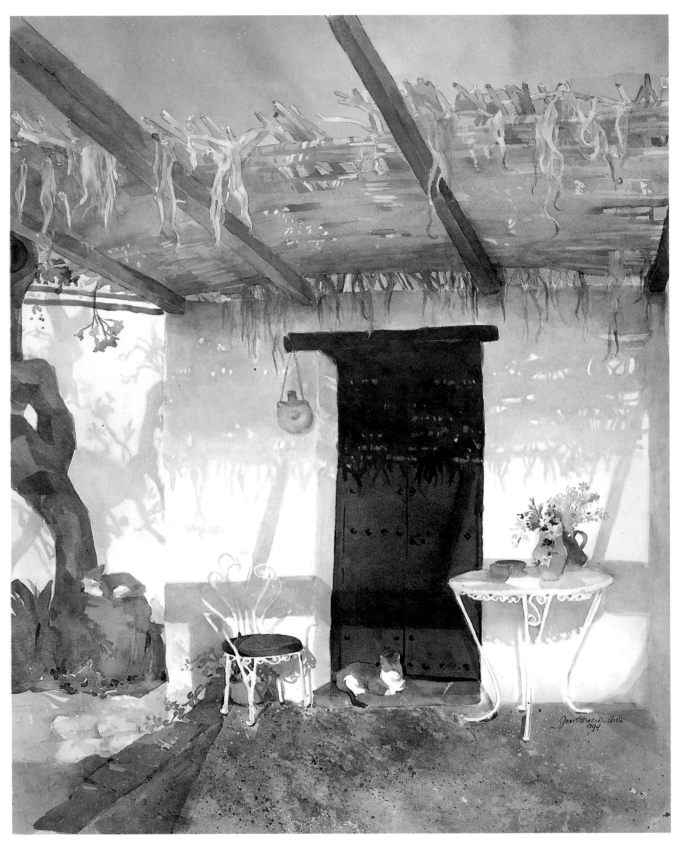

Siesta

Watercolor on 140-lb. Arches cold-pressed. 23¹/₂ x 25 inches (60 x 63.5 cm). Collection of the artist.

I had particular fun designing all the letters, and the variety of shapes that can be found in the reed roof and the cast shadow. My two feline models helped me give the painting its name.

DEMONSTRATION: KELLY

During a courtyard demonstration I was conducting in St. Paul-de-Vence, a young girl sat down on the fountain next to me. I took my camera out and quickly snapped several photographs. I don't know her name, but decided to call both her and the painting "Kelly." I based this painting on my sketches of the fountain and my photographs of my young model. My goals here were to make the light pattern lead the eye to her, and to create the texture of the wall for which the city is so well known. I achieved this by spraying White Mask through a mister.

I applied washes of blue-violet and yellows to most of the painting, with the exception of the girl and the lightest areas. I mixed the color directly on the paper to enhance the desired texture.

This stage shows how I began to integrate the form of the young girl into the background.

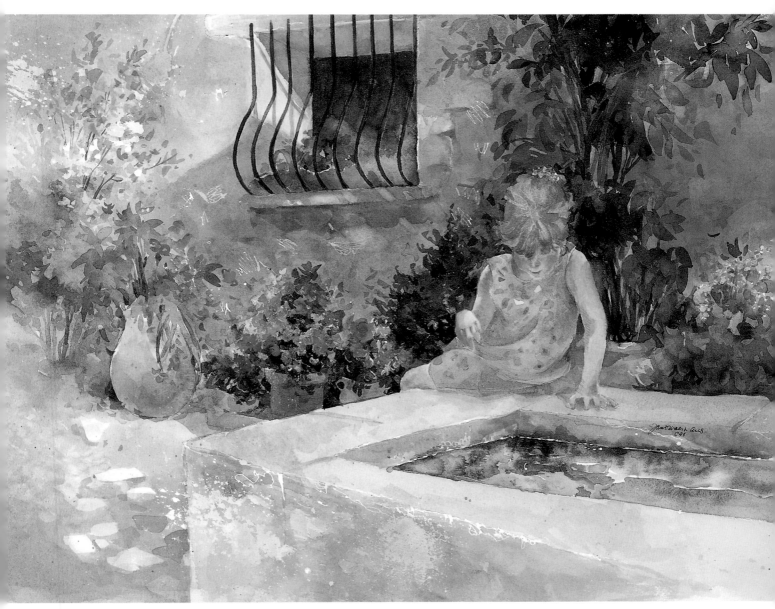

KELLY
Watercolor on 140-lb. Fabriano cold-pressed.
16 x 20¾ inches (47.6 x 53.7 cm). Collection of the artist.

The walls were given two glazes of color and the light pattern on the window sill was established. This light pattern carries the eye to "Kelly" from the left. The light section of the top of the fountain will bring the eye from the right. My primary concern in painting the water was not to lose either the girl's reflection or the small ball. These were painted in first, and then the remainder of the water was painted wet-in-wet, repeating sky, foliage, and the colors I used to paint the girl.

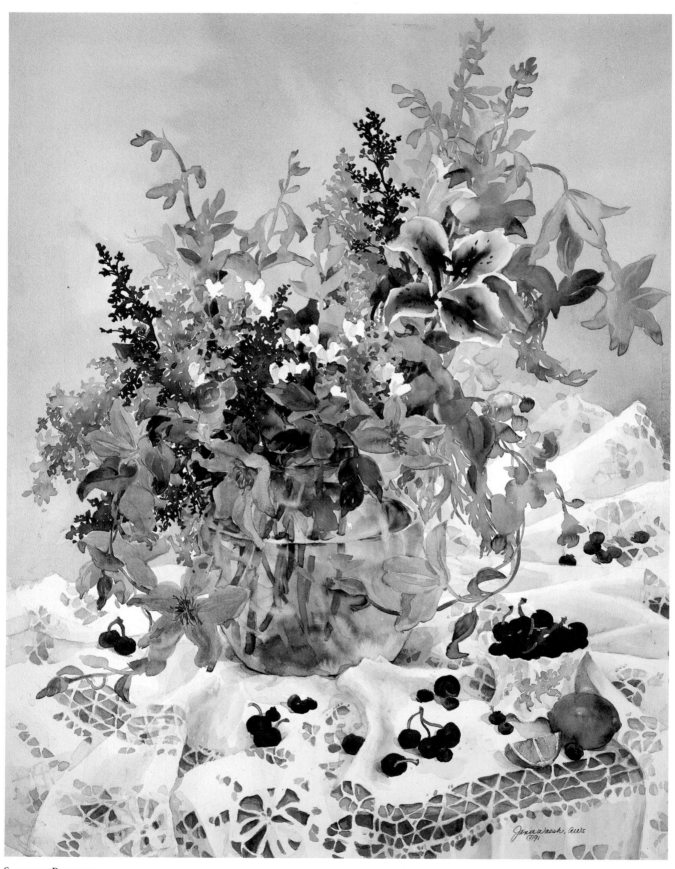

Summer Bounty
Watercolor on 140-lb. Fabriano cold-pressed. 22 x 30 inches (55.9 x 76.2 cm). Private collection.

Selected Bibliography

Brommer, Gerald F. *Understanding Transparent Watercolor.* Worcester, Massachusetts: Davis Publications, 1993.

Clinch, Moira, ed. *Watercolor Painter's Pocket Palette.* Cincinnati, Ohio: North Light Publishers, 1991.

Cooper, Mario. *Flower Painting in Watercolor.* New York: Van Nostrand Reinhold Company, 1980.

———. *Watercolor by Design.* New York: Watson-Guptill Publications, 1980.

———. *The Art of Drapery.* New York: Van Nostrand Reinhold Company, 1983.

Cox, Madison. *Artists' Gardens.* New York: Harry N. Abrams, Inc., 1993.

Dobie, Jeanne. *Making Color Sing.* New York: Watson-Guptill Publications, 1986.

Dodson, Bert. *Keys to Drawing.* Cincinnati, Ohio: North Light Publishers, 1985.

Edwards, Betty. *Drawing on the Right Side of the Brain.* Boston: Houghton Mifflin Co., 1979.

Griffiths, Jerry. *Using Liquid Frisket.* Cambridge, Massachusetts: Graphic Systems, Inc., 1993.

Griswold, Mac. *Pleasures of the Garden: Images from the Metropolitan Museum of Art.* New York: Harry N. Abrams, Inc., 1987.

Le Clair, Charles. *Color in Contemporary Painting: Integrating Practice and Theory.* New York: Watson-Guptill Publications, 1991.

Madderlake. *Flowers Rediscovered.* New York: Stewart, Tabori & Chang, 1985.

Meyers, Dale. *The Sketchbook.* New York: Van Nostrand Reinhold, 1983.

Murray, Elizabeth. *Monet's Passion.* Petaluma, California: Pomegranate Artbooks, Inc., 1989.

———. *Painterly Photography: Awakening the Artist Within.* Petaluma, California: Pomegranate Artbooks, Inc., 1993.

Nicolaides, Kimon. *The Natural Way to Draw.* Boston: Houghton Mifflin Co., 1969.

Quiller, Stephen. *Color Choices.* New York: Watson-Guptill Publications, 1989.

Reed, Sue Welsh, and Carol Troyen. *Awash in Color: Great American Watercolorists.* Boston: Bulfinch Press, 1993.

Reid, Charles. *Figure Painting in Watercolor.* New York: Watson-Guptill Publications, 1979.

———. *Painting by Design: Getting to the Essence of Good Picture-Making.* New York: Watson-Guptill Publications, 1991.

Ryerson, Margery. *The Art Spirit.* New York: Harper & Row, 1984.

Sloan, John. *The Gist of Art.* New York: Dover Publications, 1967.

Strickland, Carol, and John Boswell. *Annotated Mona Lisa: A Crash Course in Art History from Prehistoric to Post-Modern.* Kansas City, Missouri: Andrews & McMeel, 1992.

Ueland, Brenda. *If You Want to Write.* St. Paul, Minnesota: Graywolf Press, 1987.

Wilcox, Michael. *Blue and Yellow Don't Make Green: Or, How to Mix the Color You Want—Every Time.* Rockport, Massachusetts: Rockport Publishers, 1989.

———. *The Wilcox Guide to the Best Watercolor Paints.* Cincinnati, Ohio: North Light Books, 1991.

Index